Email us at

kids.selected@gmail.com

to get extra freebies!

Just title the email "**Scissor Cutting Skills**"
And we will send some printable freebies surprises your way!

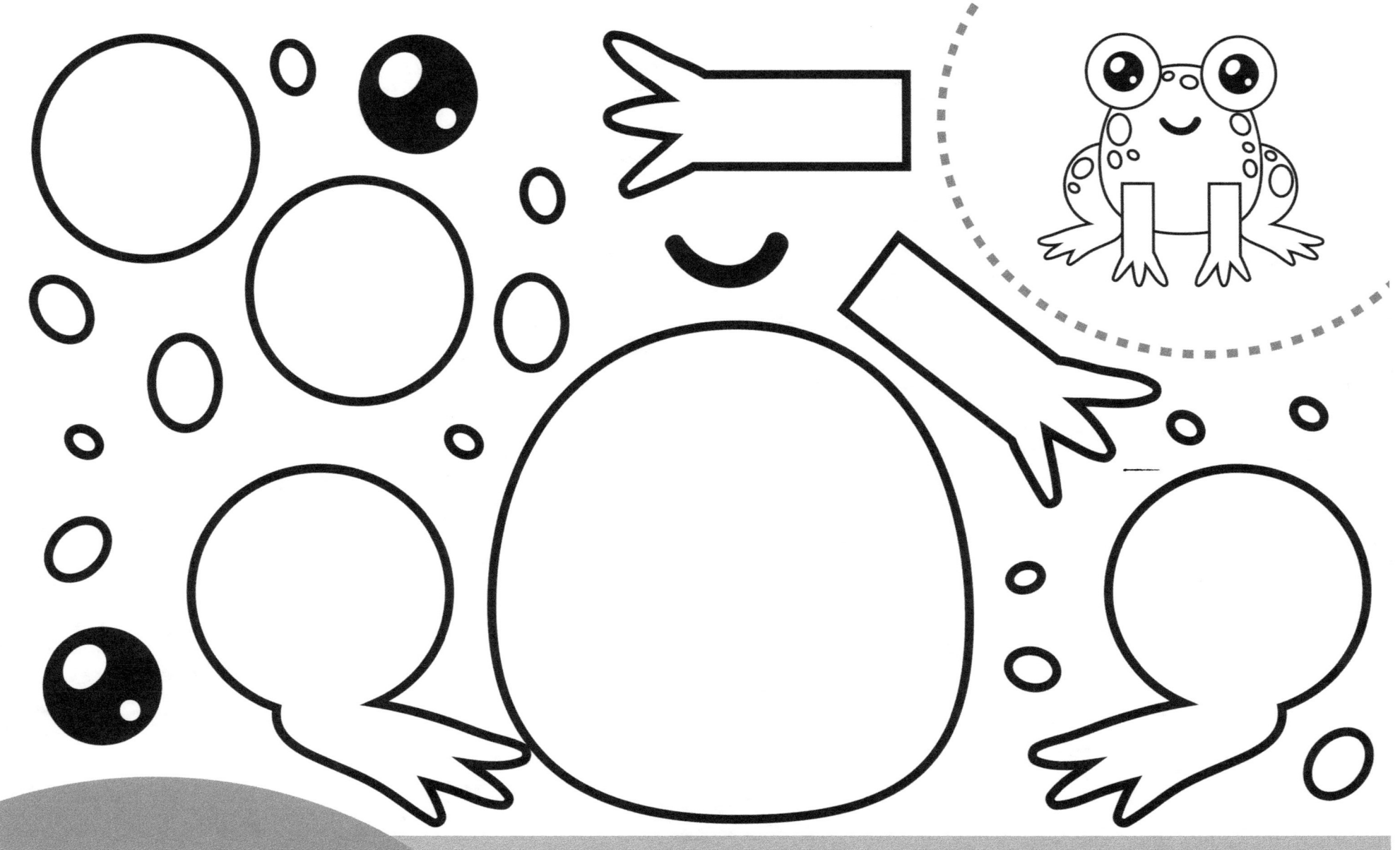

CUT & GLUE

COLOR 1 CUT OUT 2 GLUE 3 USE EXAMPLE OR YOUR IMAGINATION

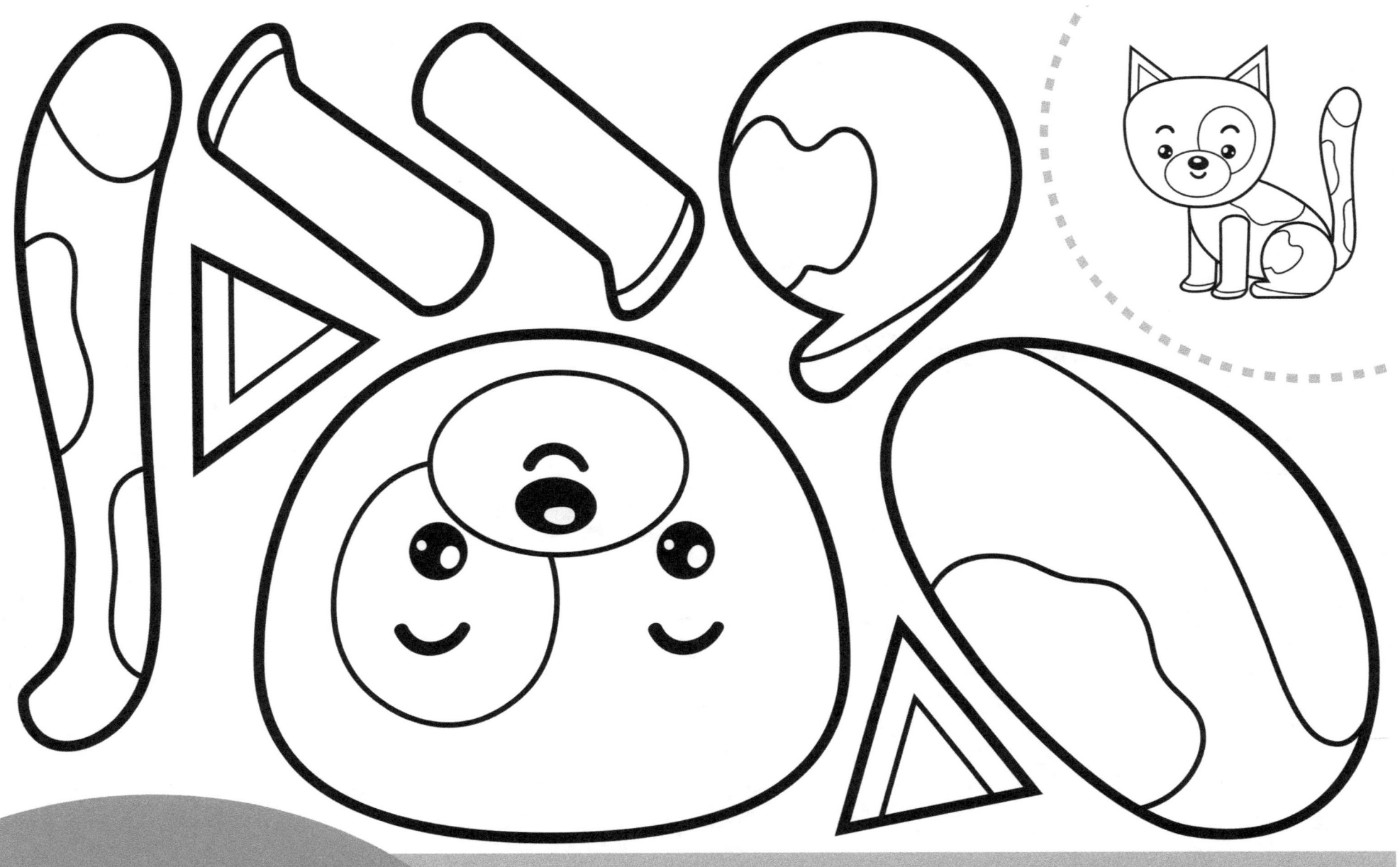

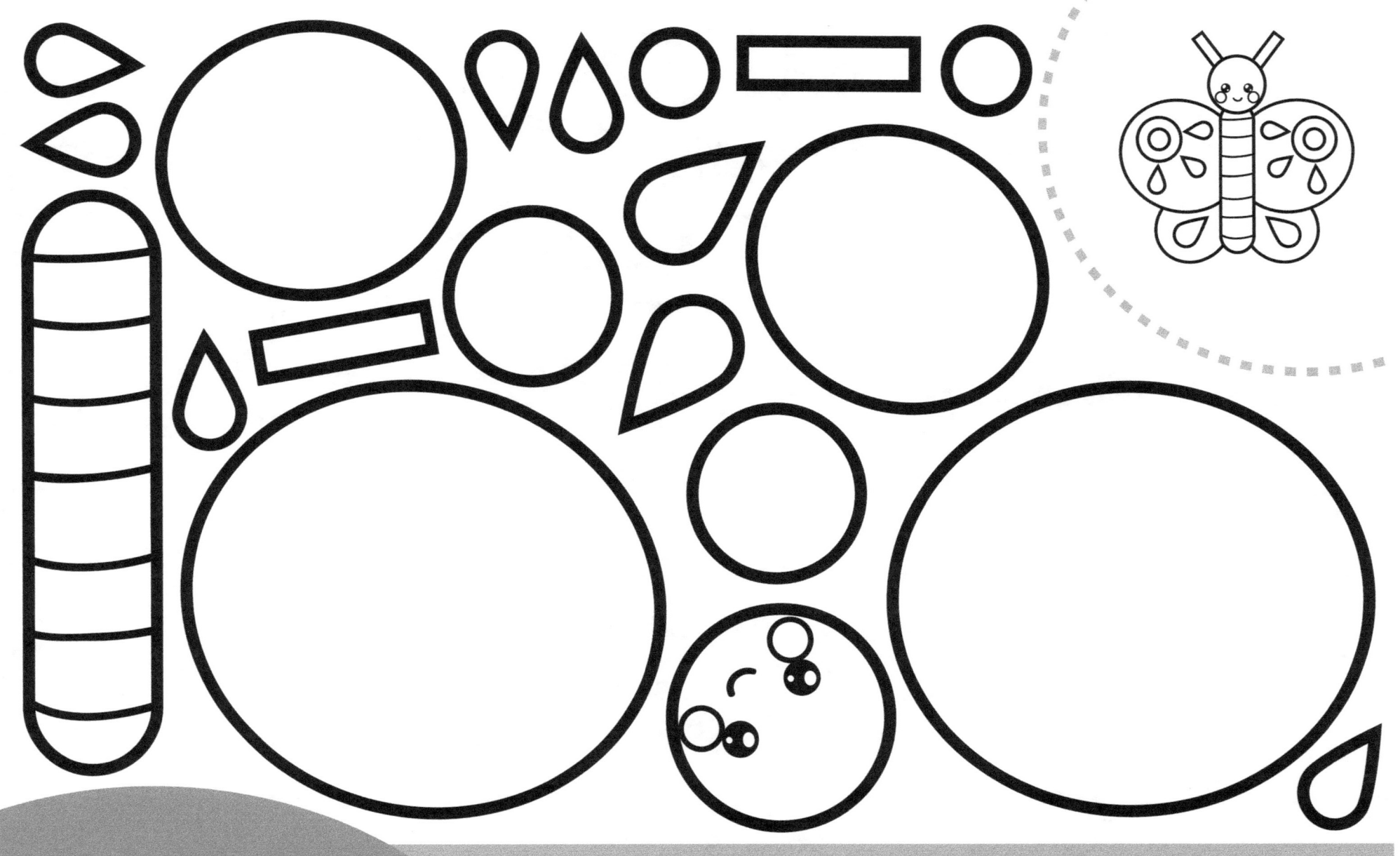

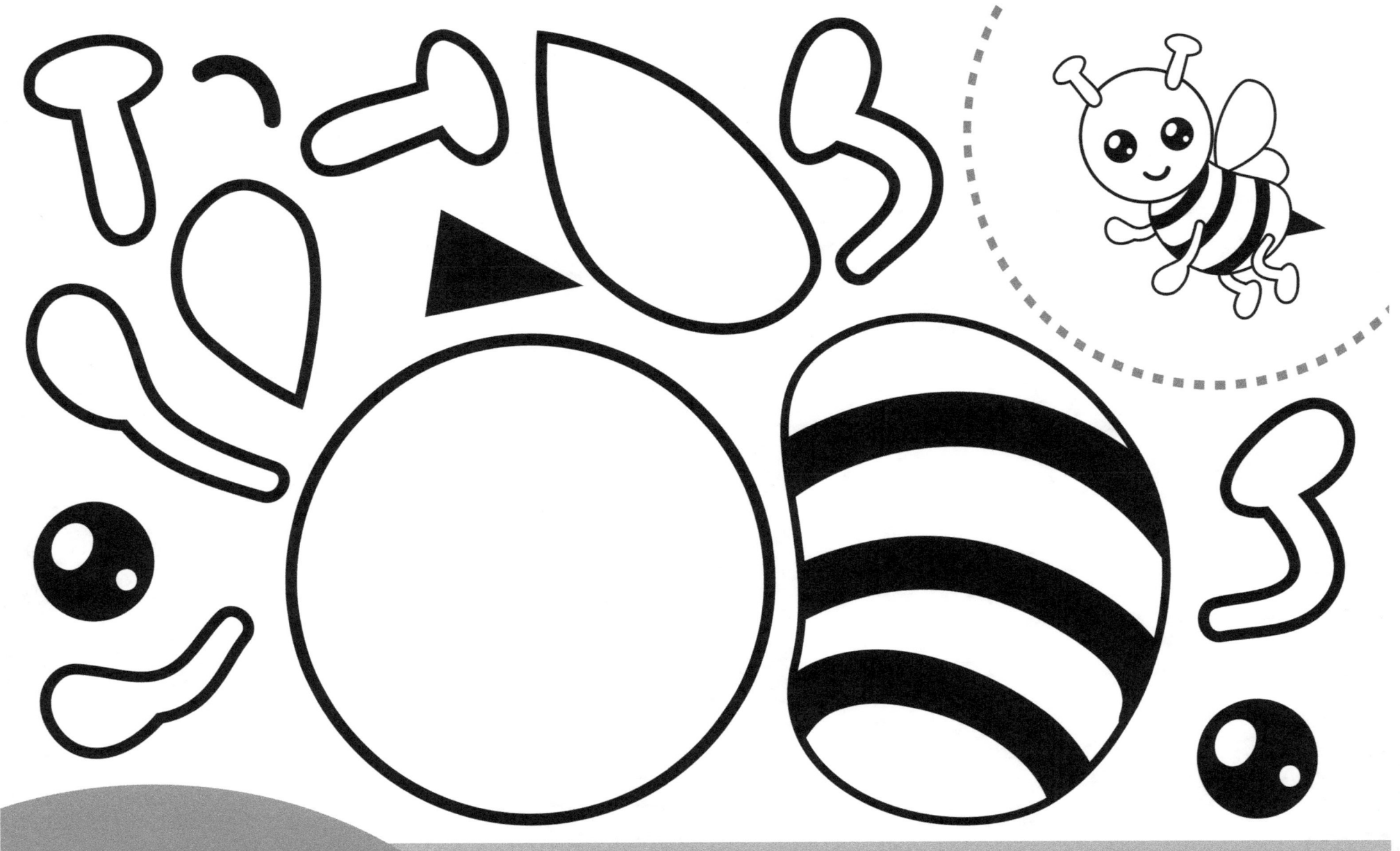

Cut & Glue

COLOR 1 — **CUT OUT** 2 — **GLUE** 3 — Use example or your imagination

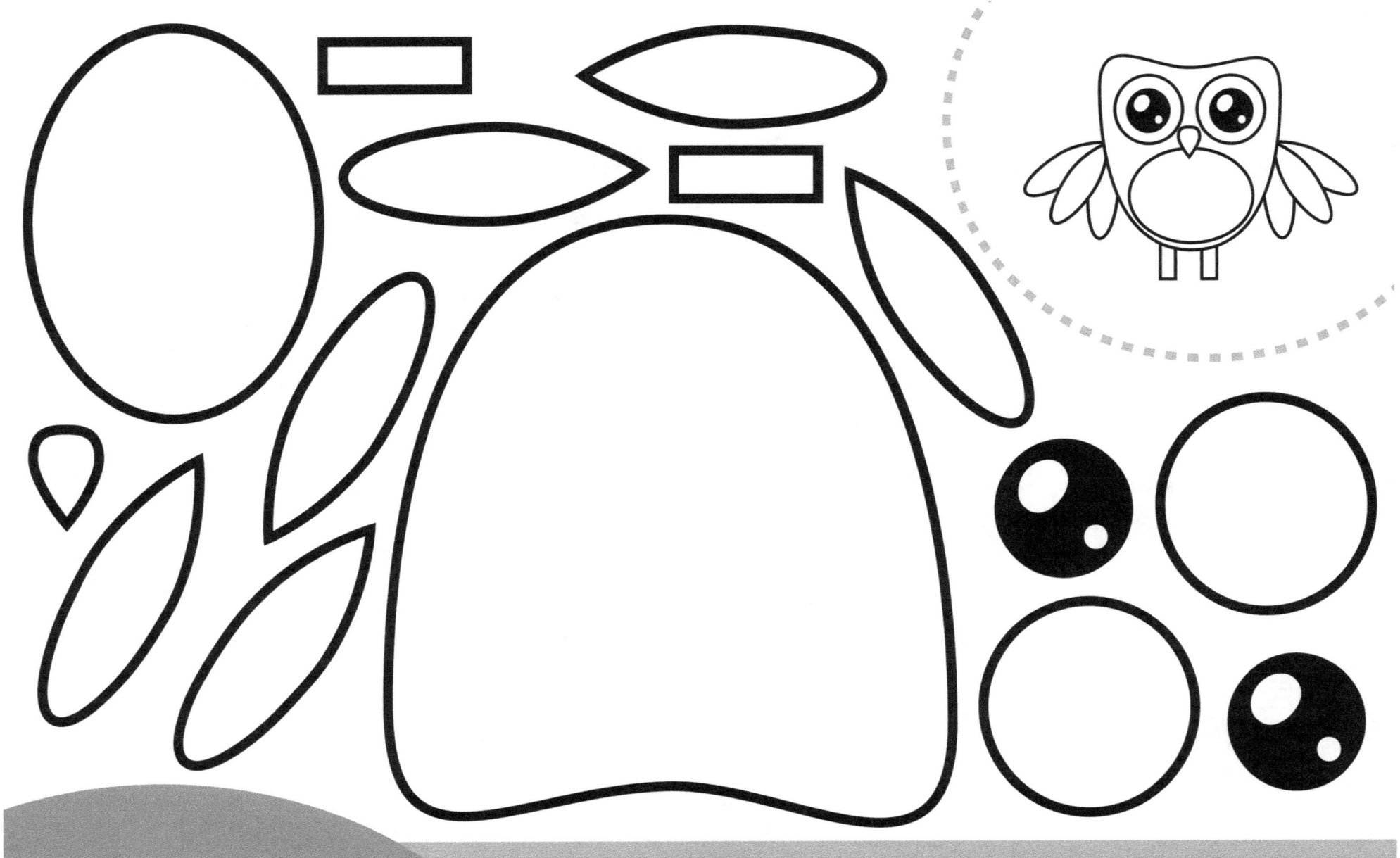

CUT & GLUE

COLOR 1 — **CUT OUT** 2 — **GLUE** 3 — USE EXAMPLE OR YOUR IMAGINATION

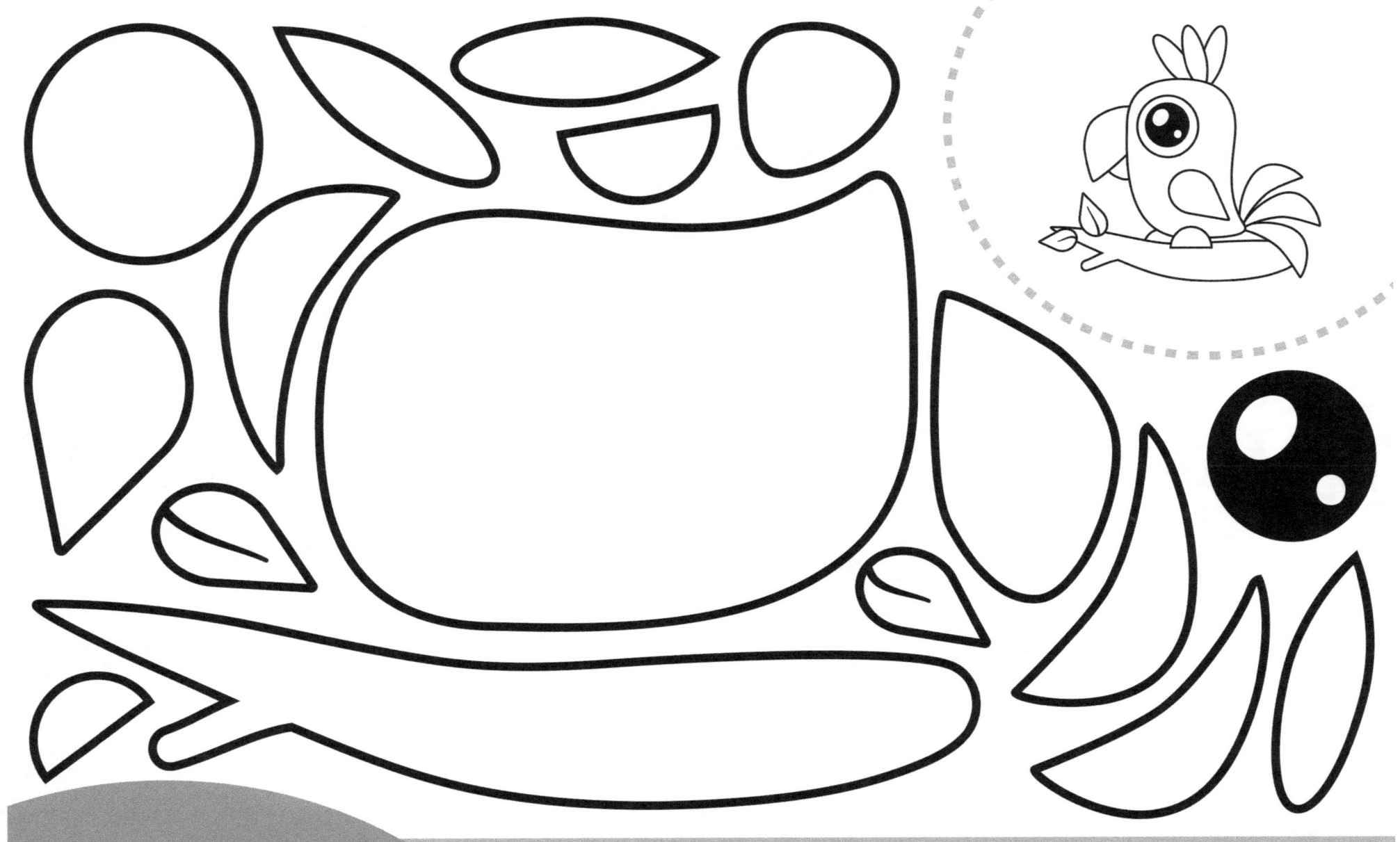

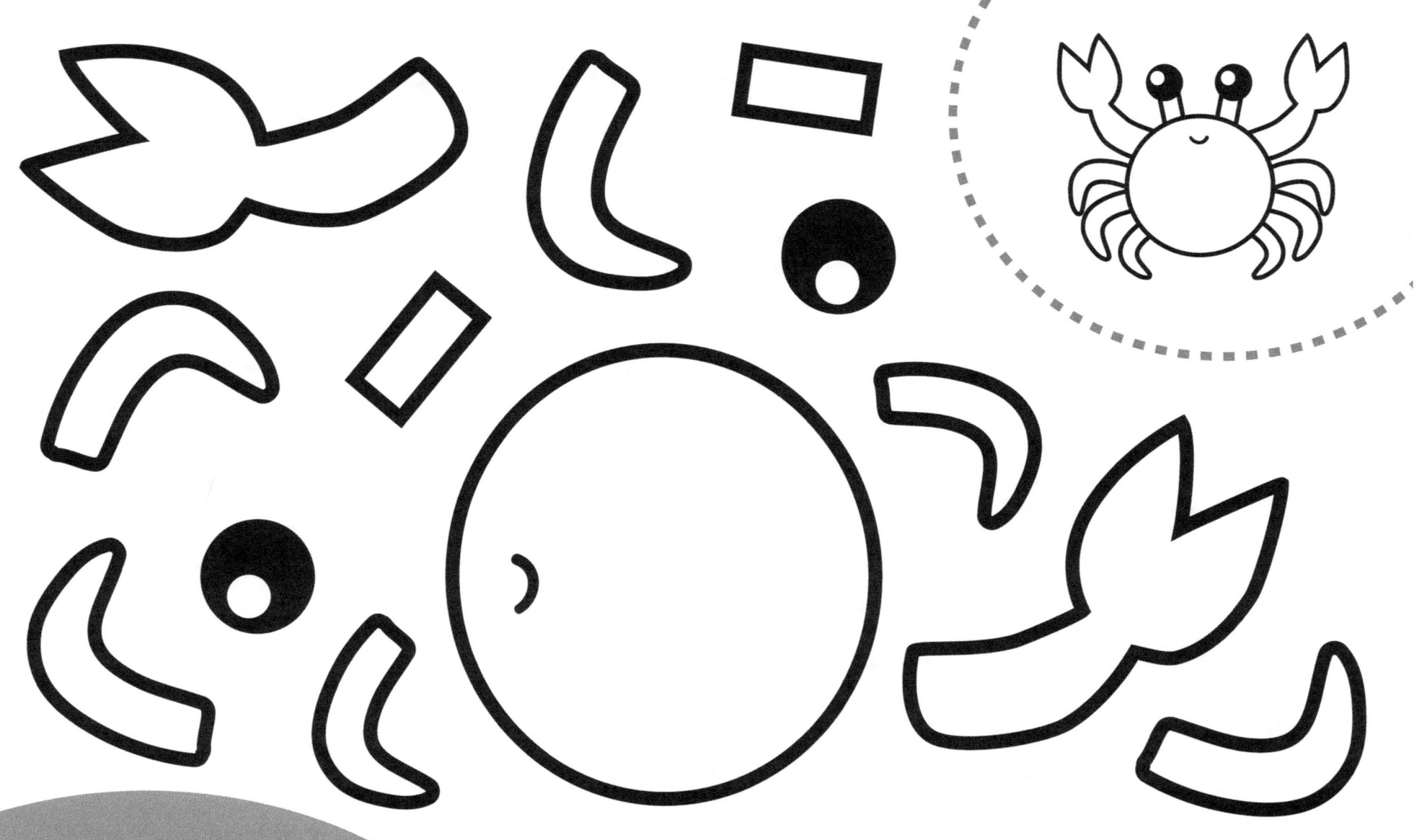

Cut & Glue

COLOR 1 — CUT OUT 2 — GLUE 3 — USE EXAMPLE OR YOUR IMAGINATION

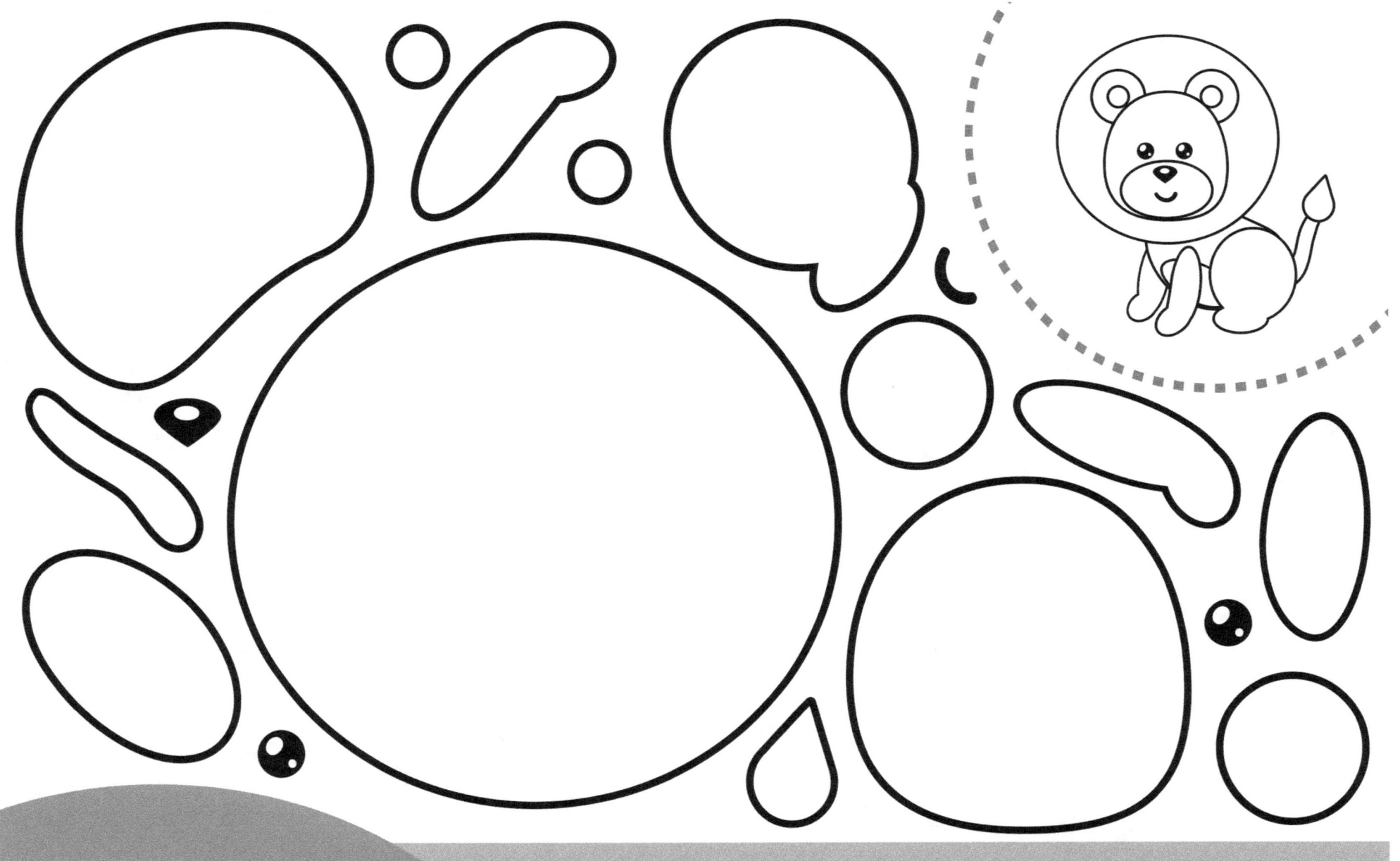

Cut & Glue

COLOR 1 · CUT OUT 2 · GLUE 3 · USE EXAMPLE OR YOUR IMAGINATION

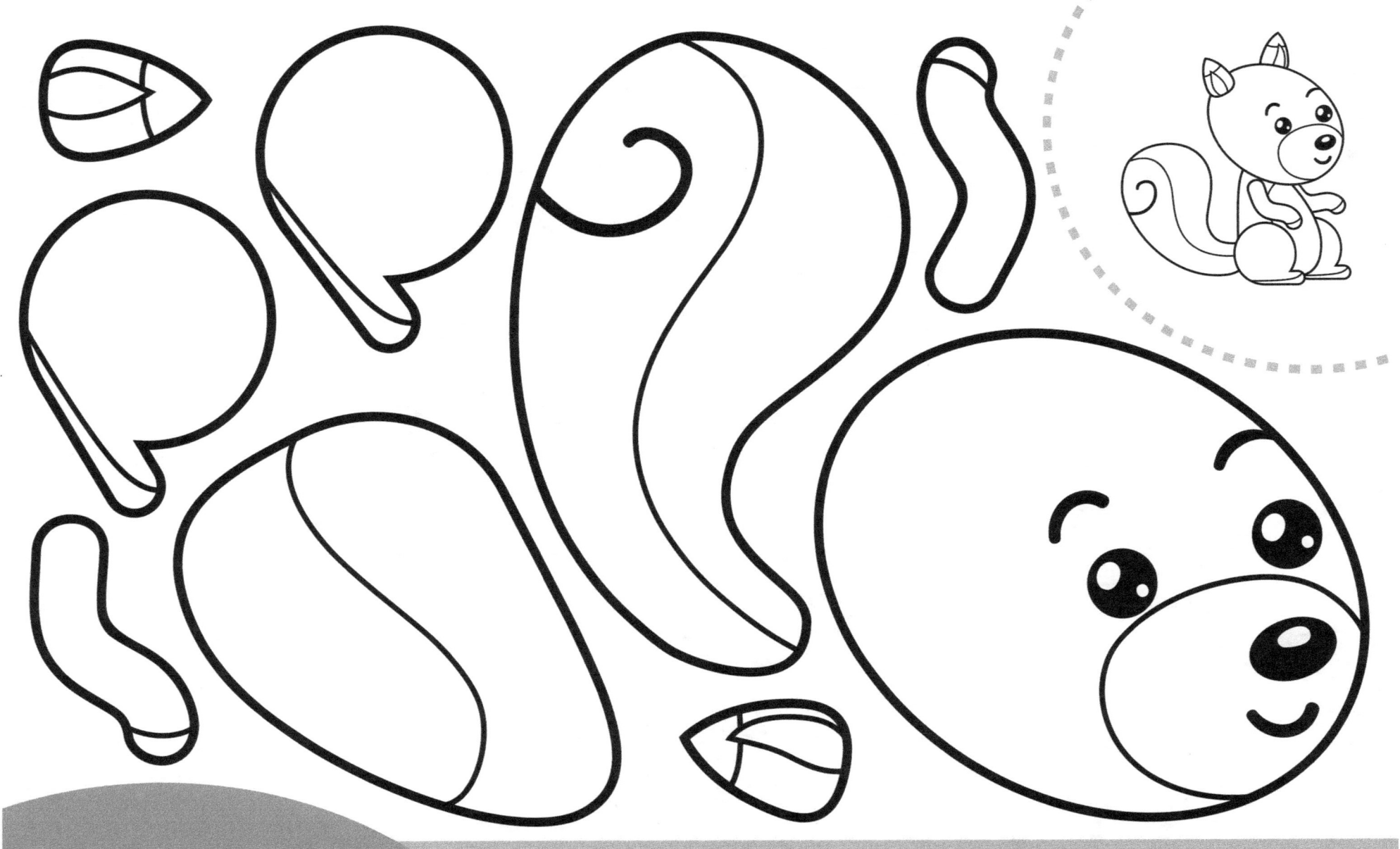

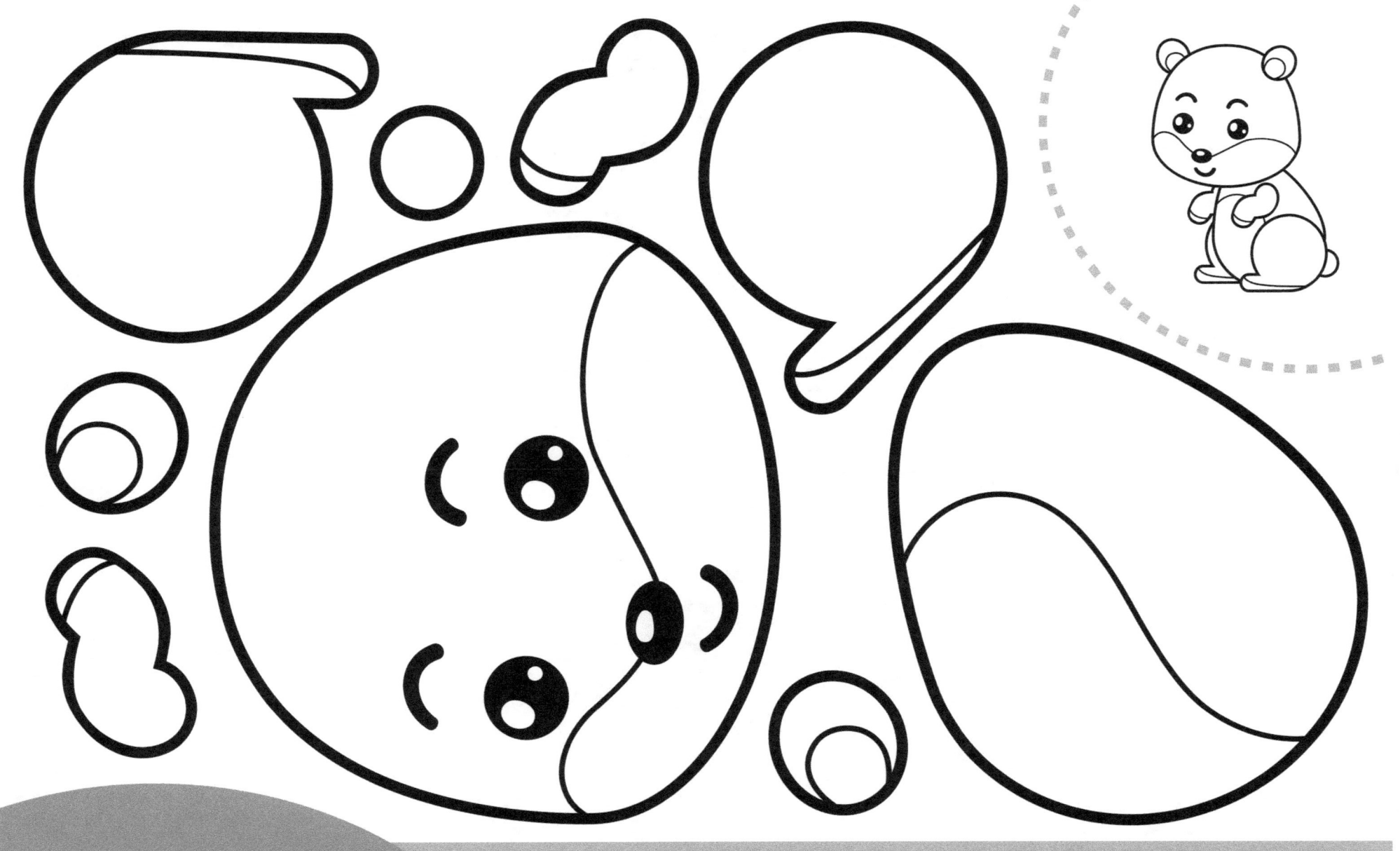

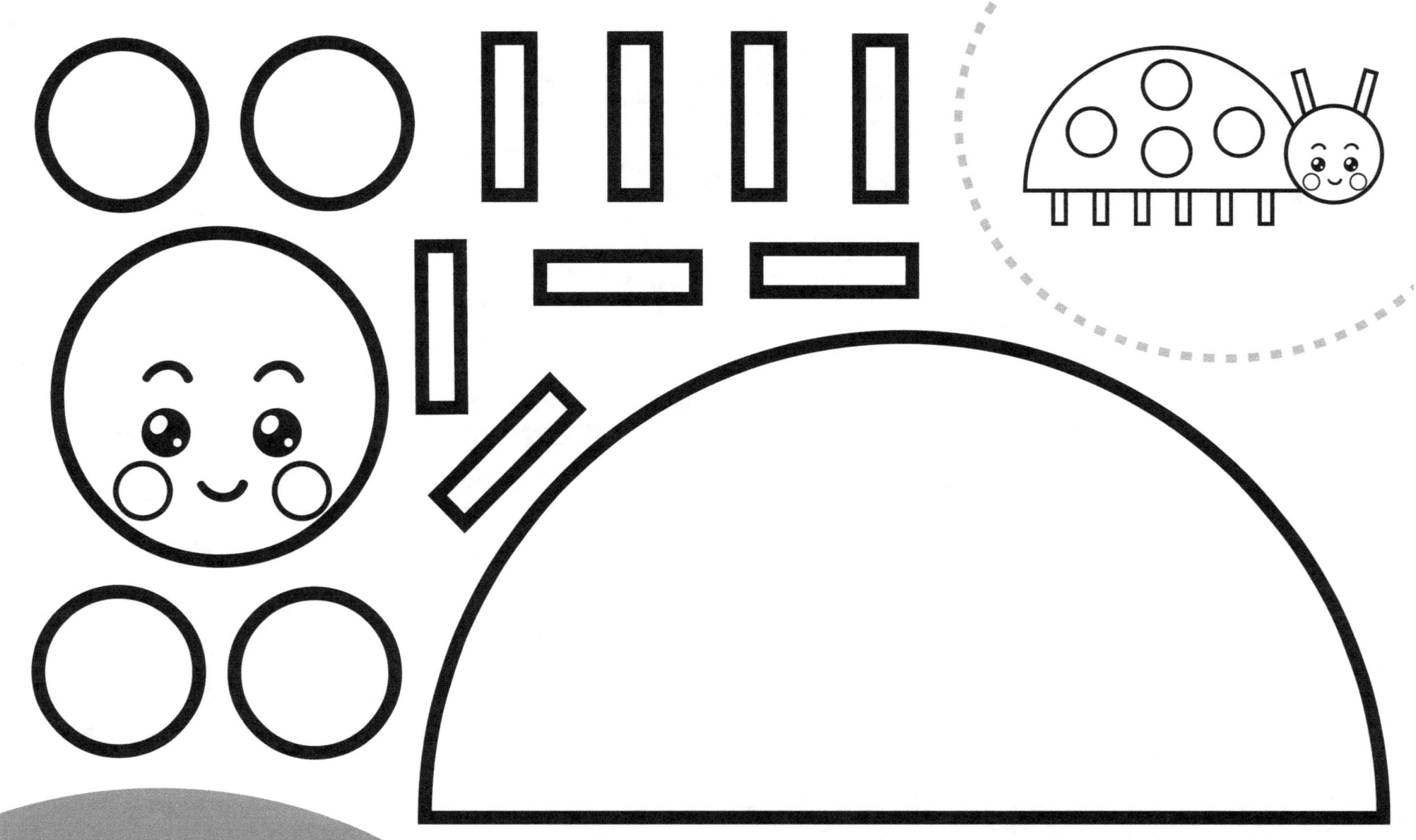

Cut & Glue

COLOR 1 · CUT OUT 2 · GLUE 3 · USE EXAMPLE OR YOUR IMAGINATION

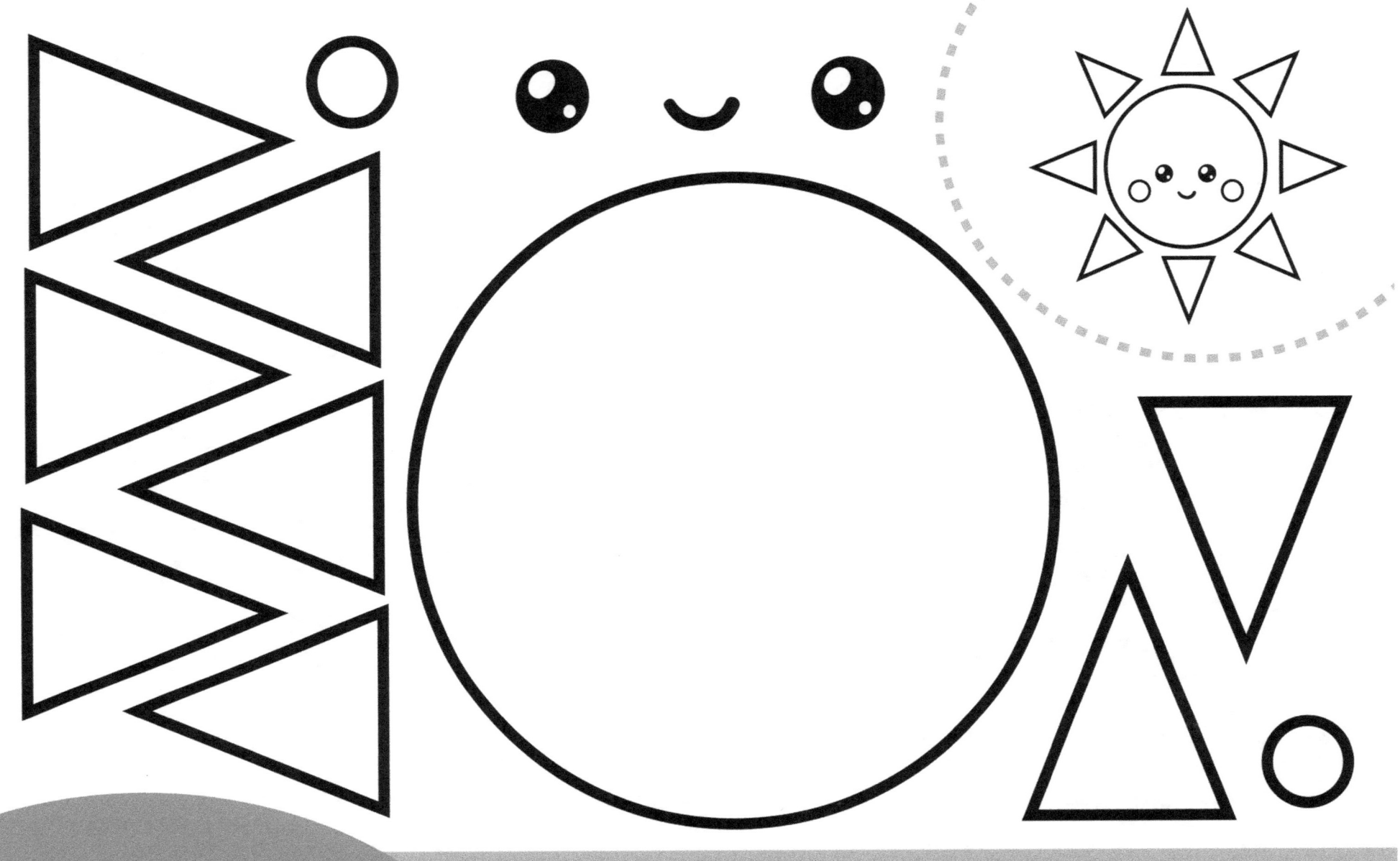

Cut & Glue

COLOR 1 · CUT OUT 2 · GLUE 3 · USE EXAMPLE OR YOUR IMAGINATION

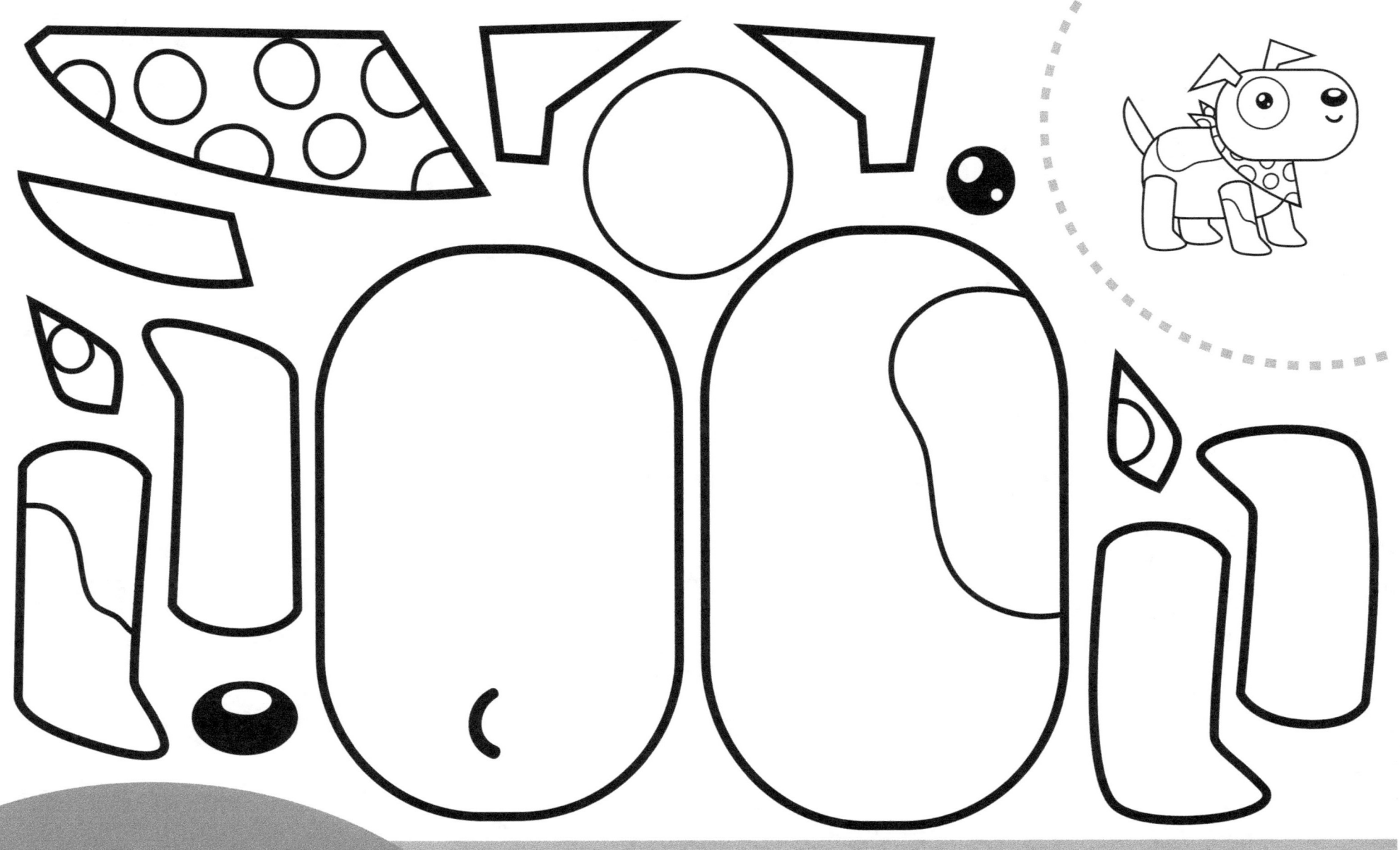

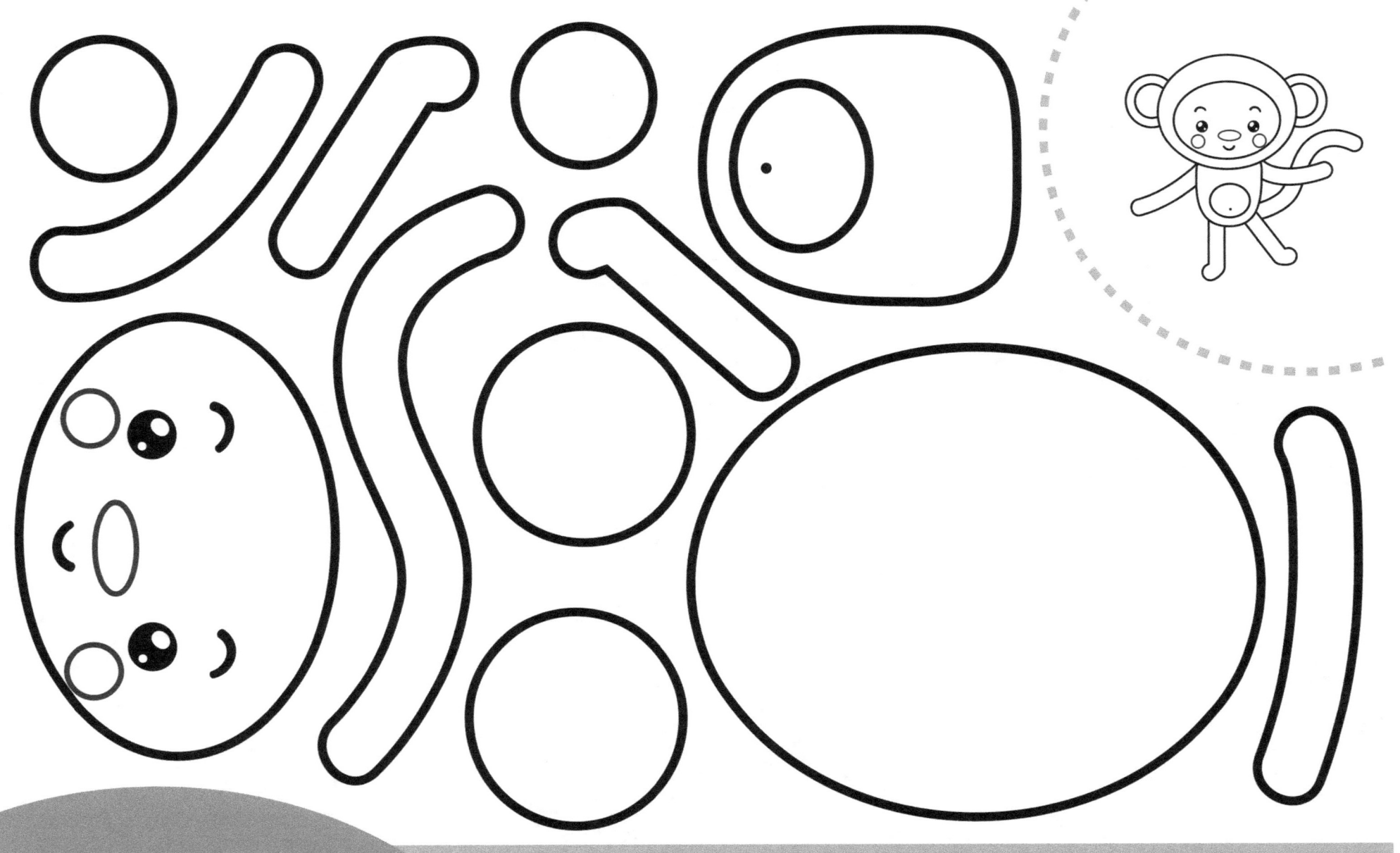

Cut & Glue

COLOR 1 — CUT OUT 2 — GLUE 3 — USE EXAMPLE OR YOUR IMAGINATION

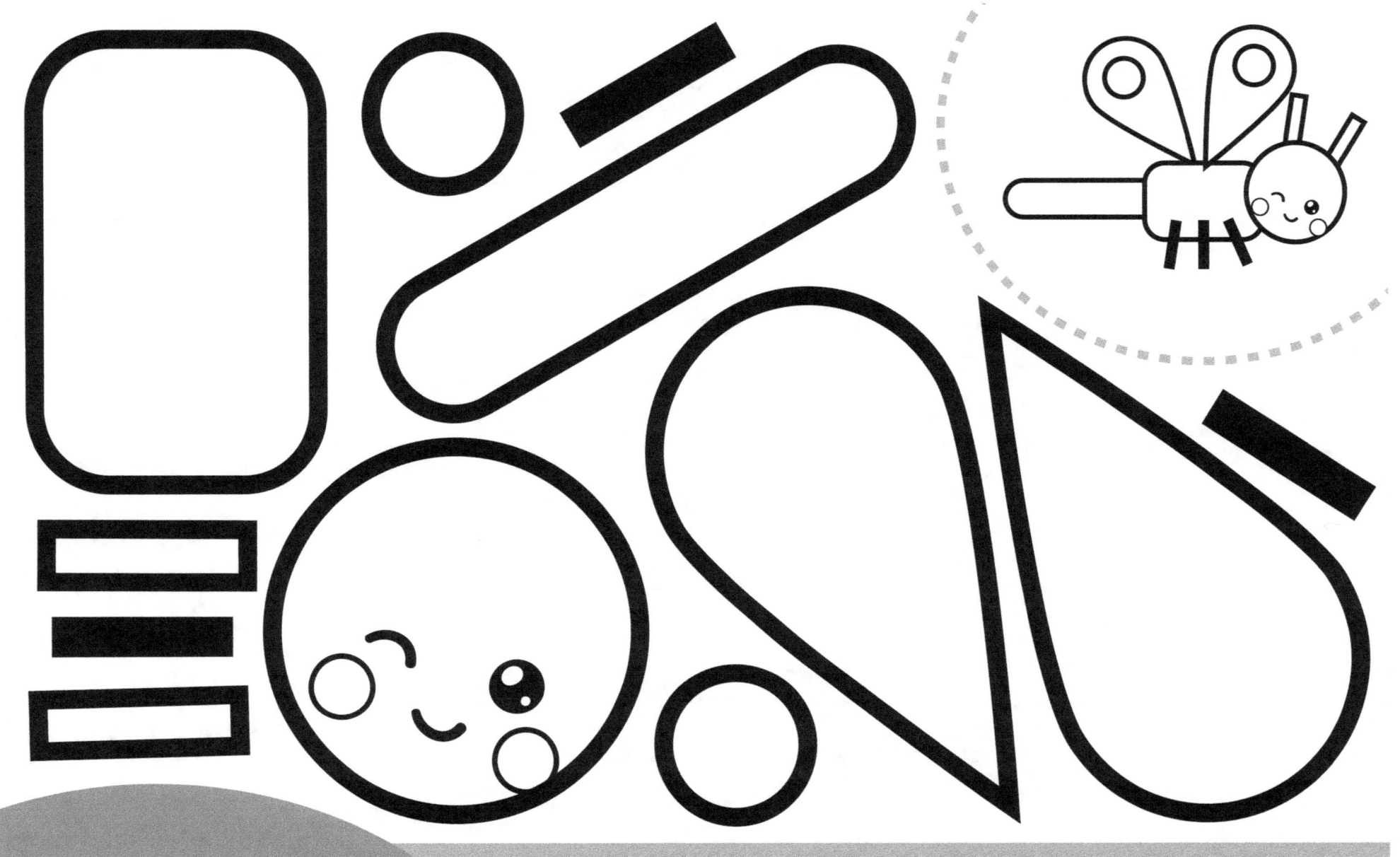

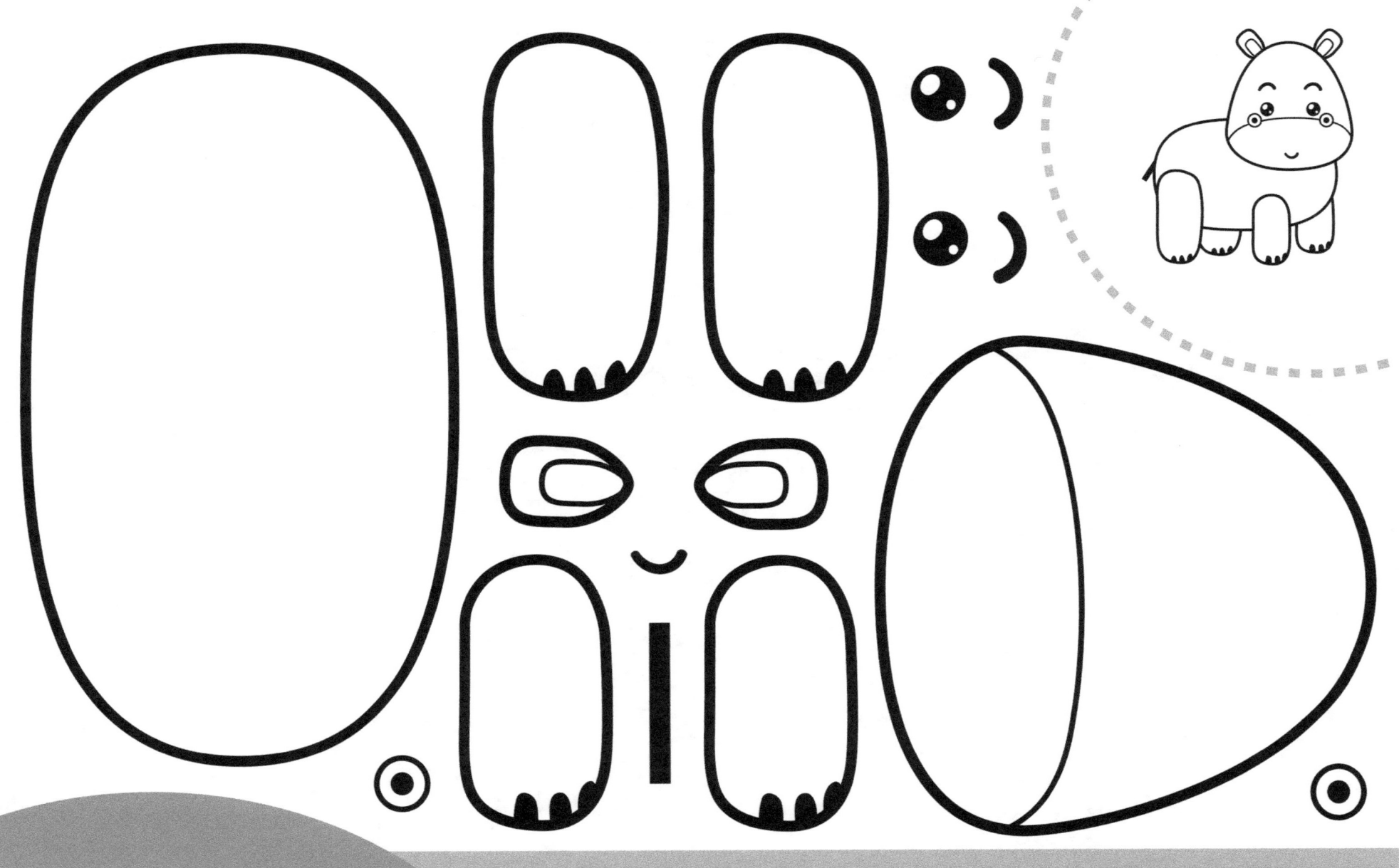

Cut & Glue

COLOR 1 • CUT OUT 2 • GLUE 3 • USE EXAMPLE OR YOUR IMAGINATION

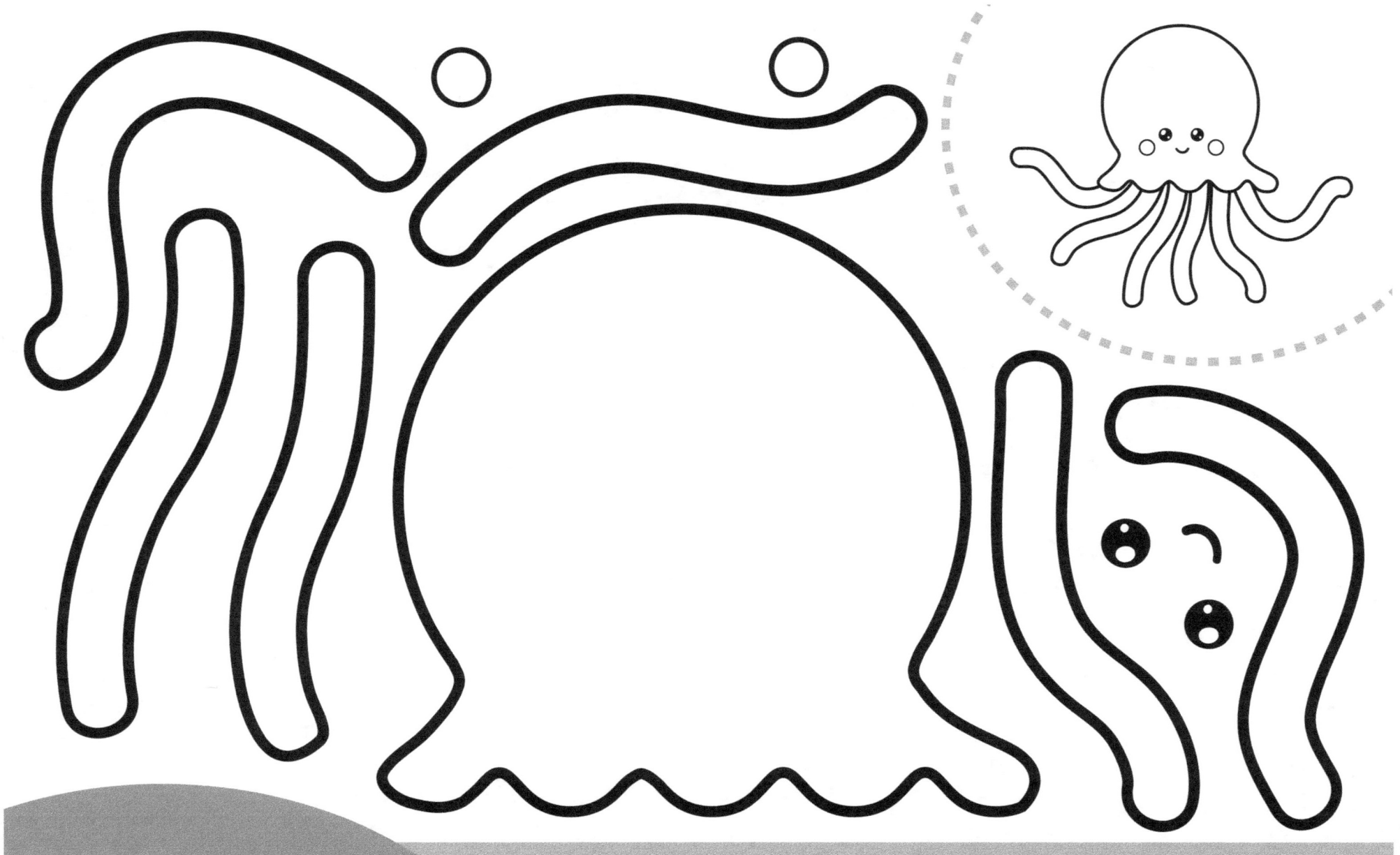

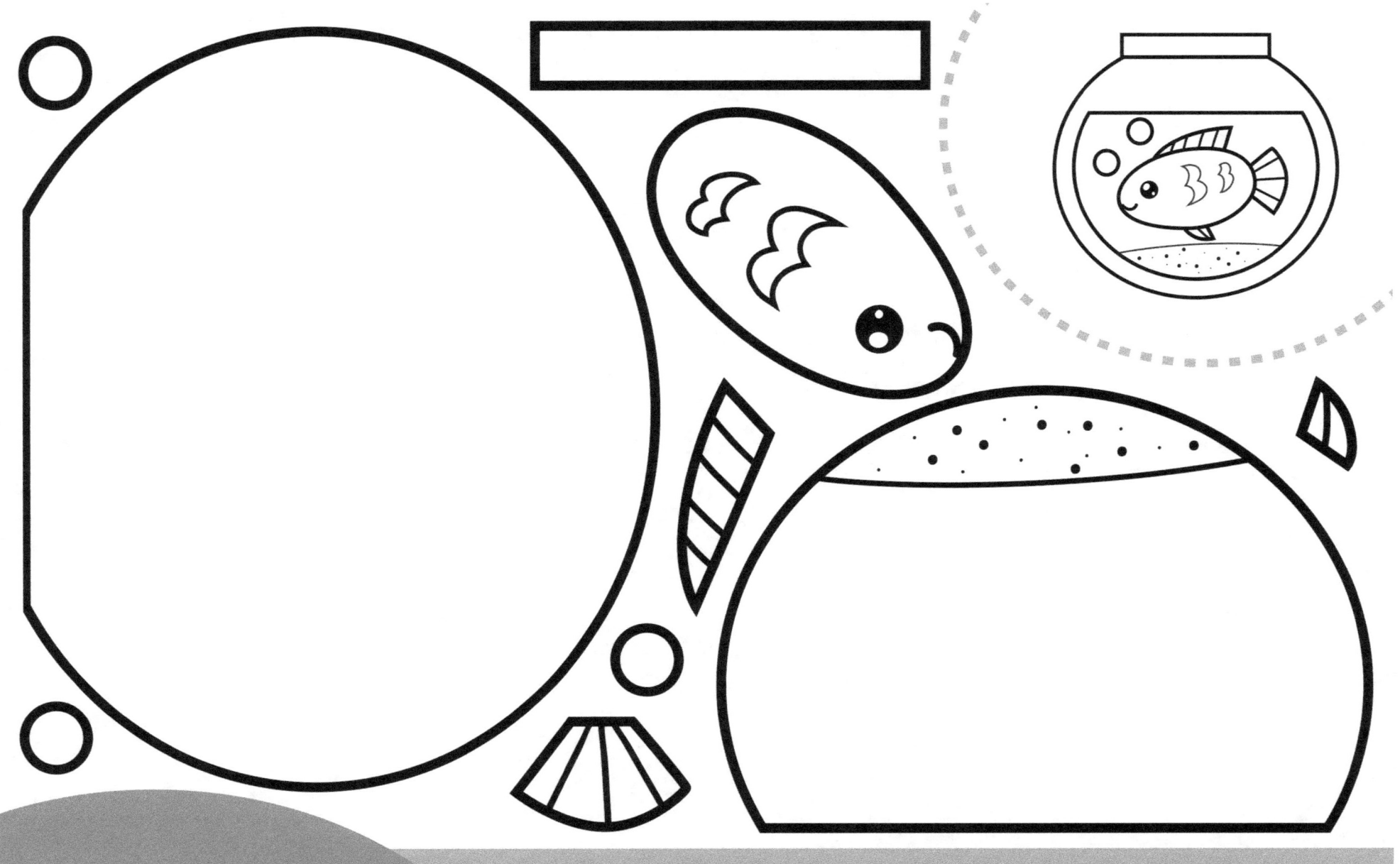

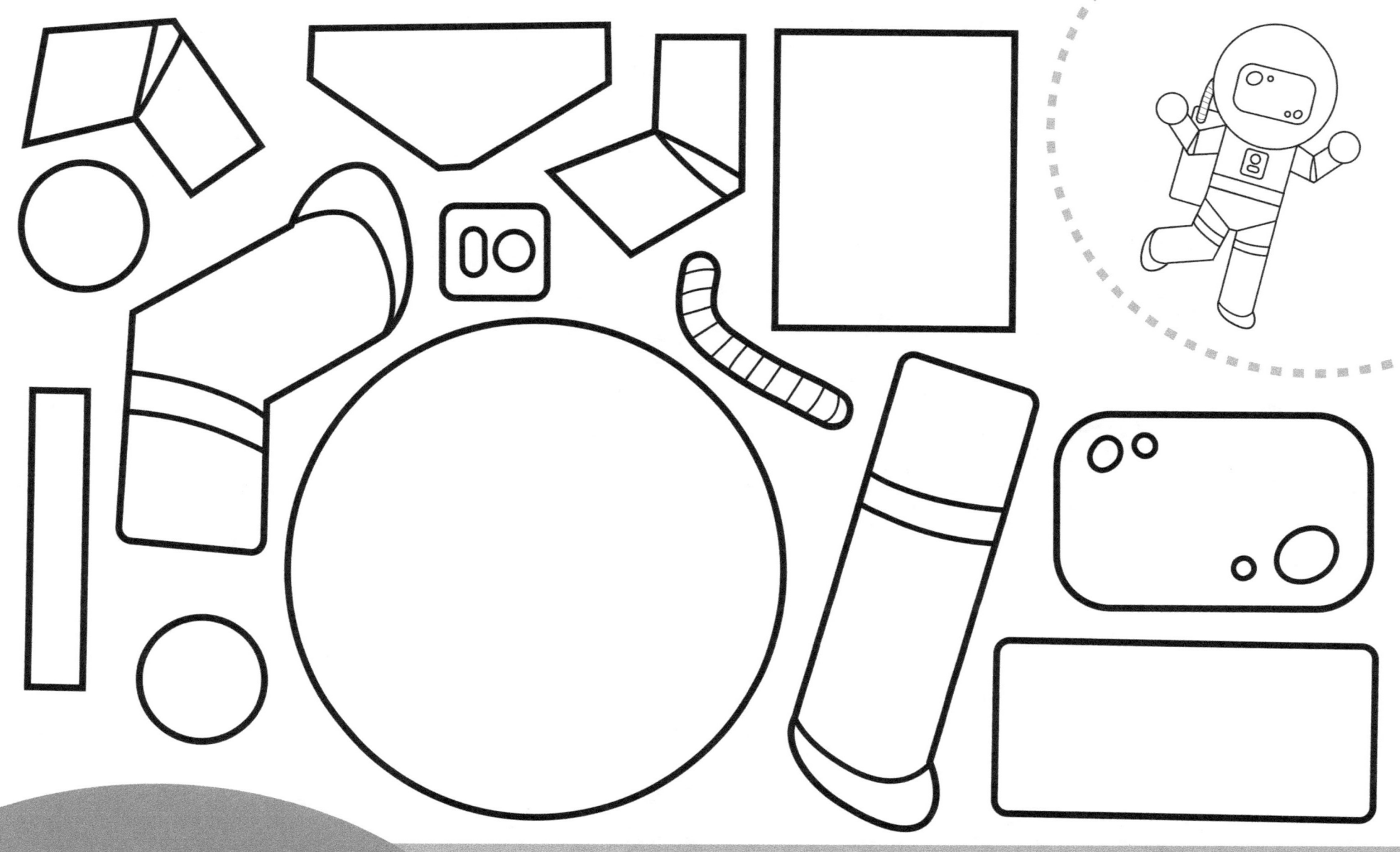

Cut & Glue

COLOR 1

CUT OUT 2

GLUE 3

USE EXAMPLE OR YOUR IMAGINATION

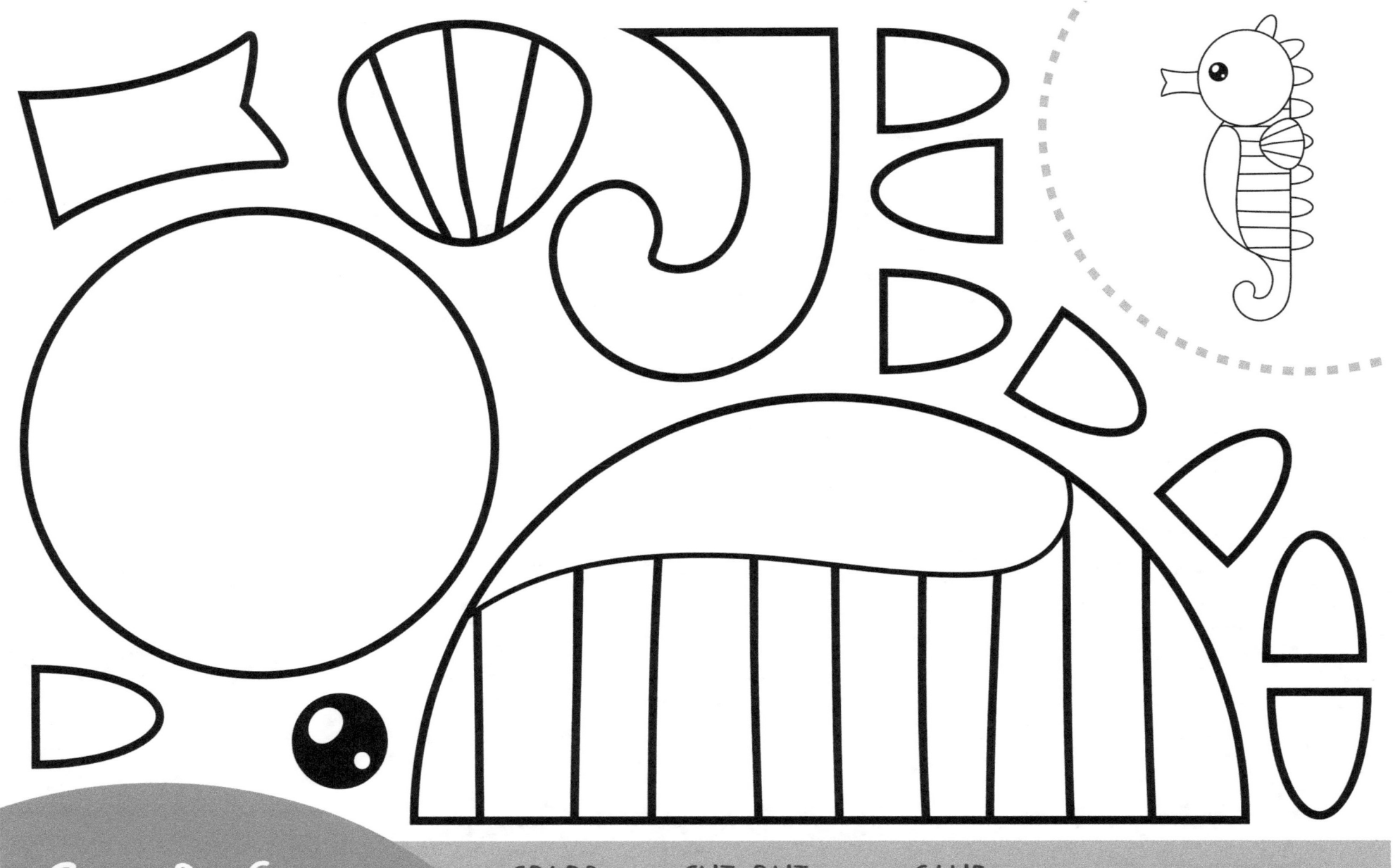

CUT & GLUE

COLOR 1

CUT OUT 2

GLUE 3

USE EXAMPLE OR YOUR IMAGINATION

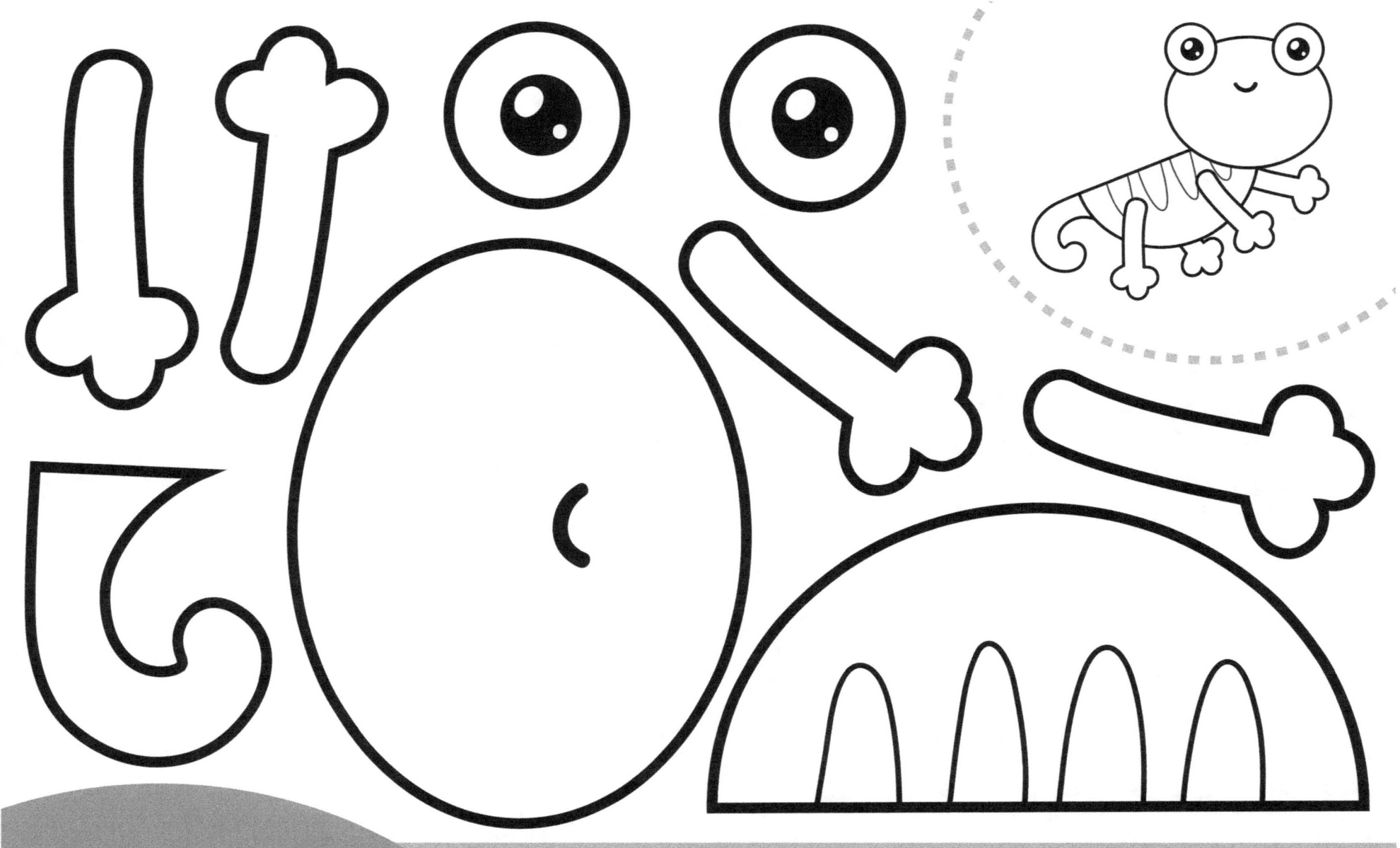

Cut & Glue

COLOR 1

CUT OUT 2

GLUE 3

USE EXAMPLE OR YOUR IMAGINATION

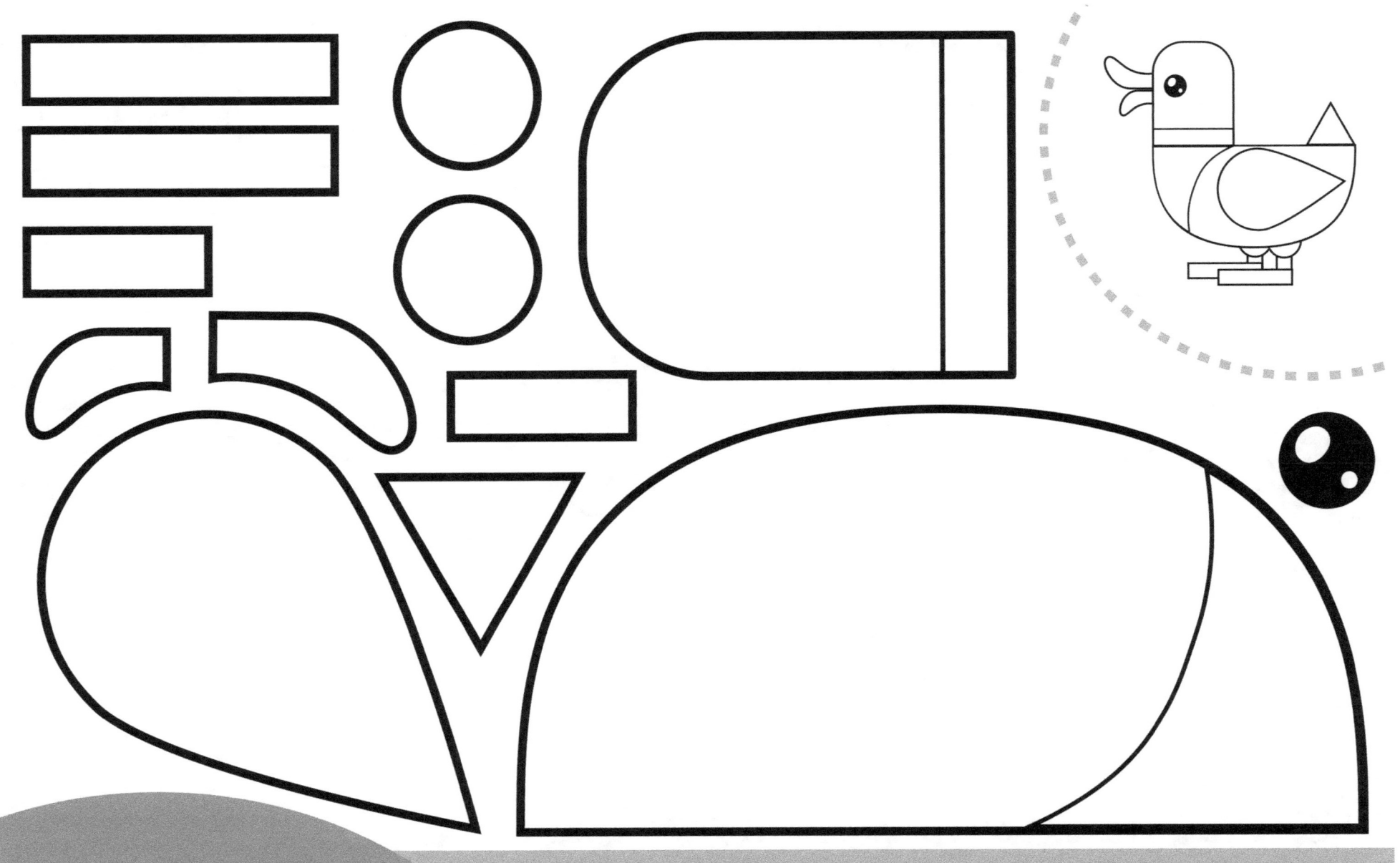

Cut & Glue

COLOR 1 — CUT OUT 2 — GLUE 3 — USE EXAMPLE OR YOUR IMAGINATION

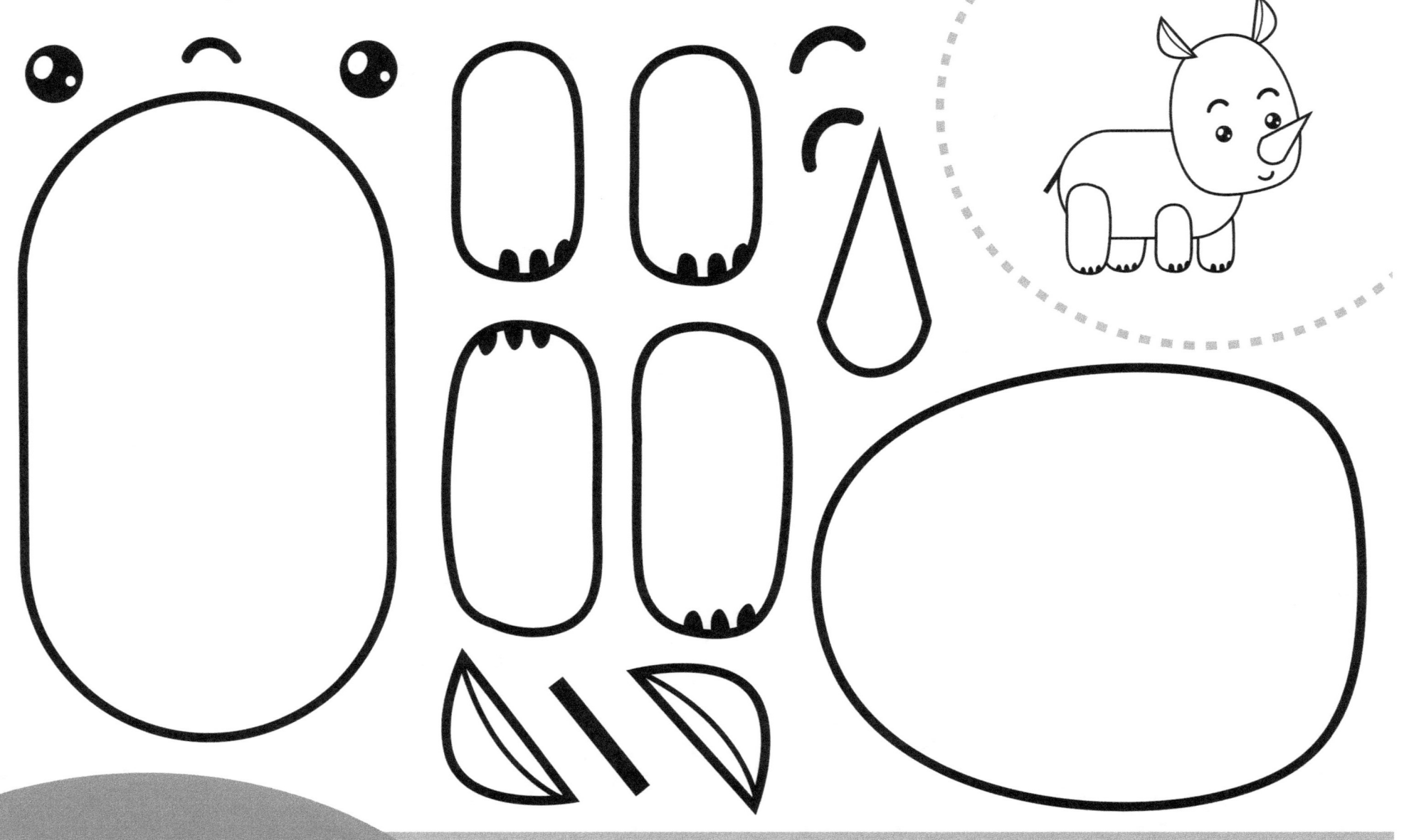

Cut & Glue

COLOR 1

CUT OUT 2

GLUE 3

USE EXAMPLE OR YOUR IMAGINATION

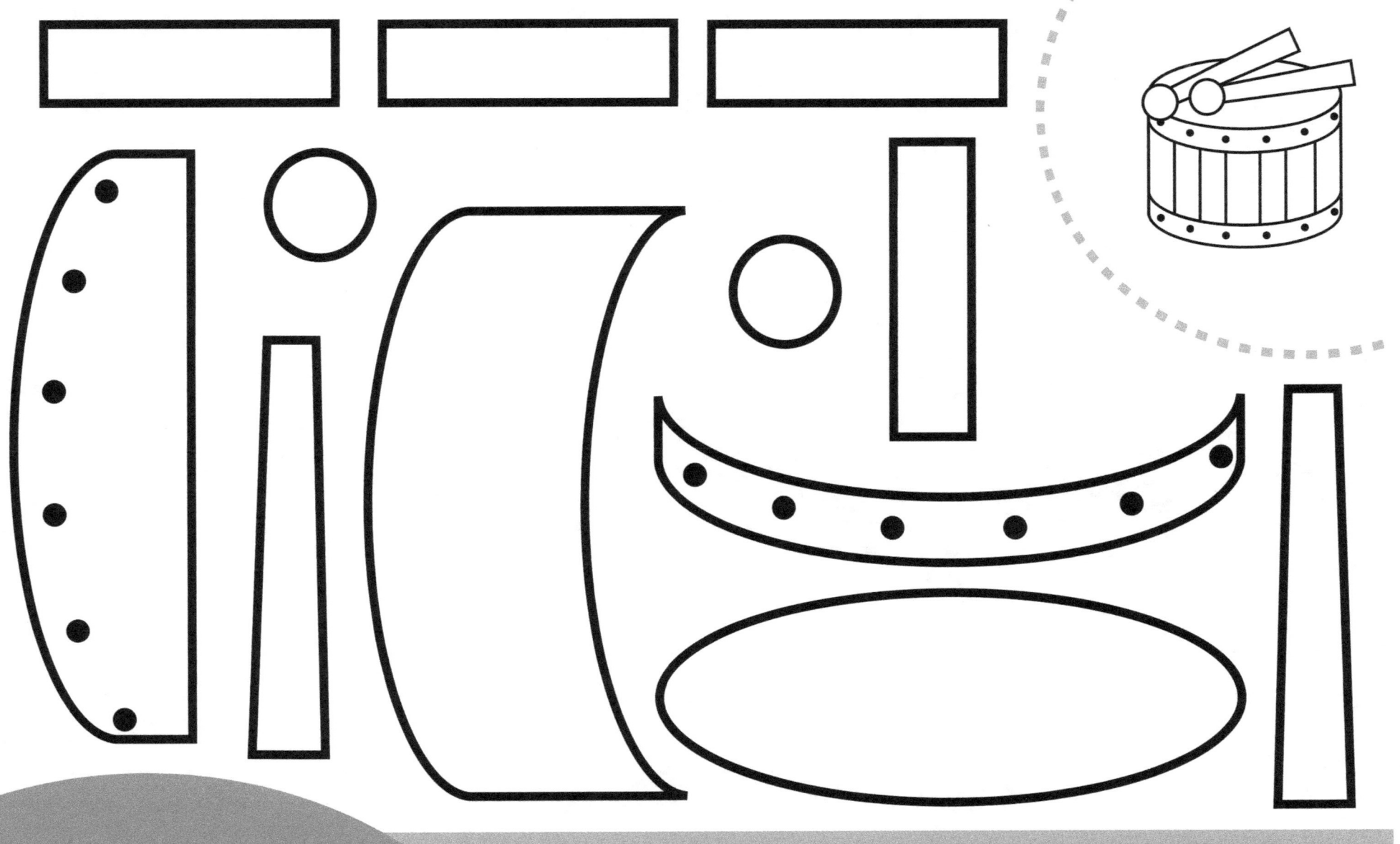

CUT & GLUE

COLOR 1

CUT OUT 2

GLUE 3

USE EXAMPLE OR YOUR IMAGINATION

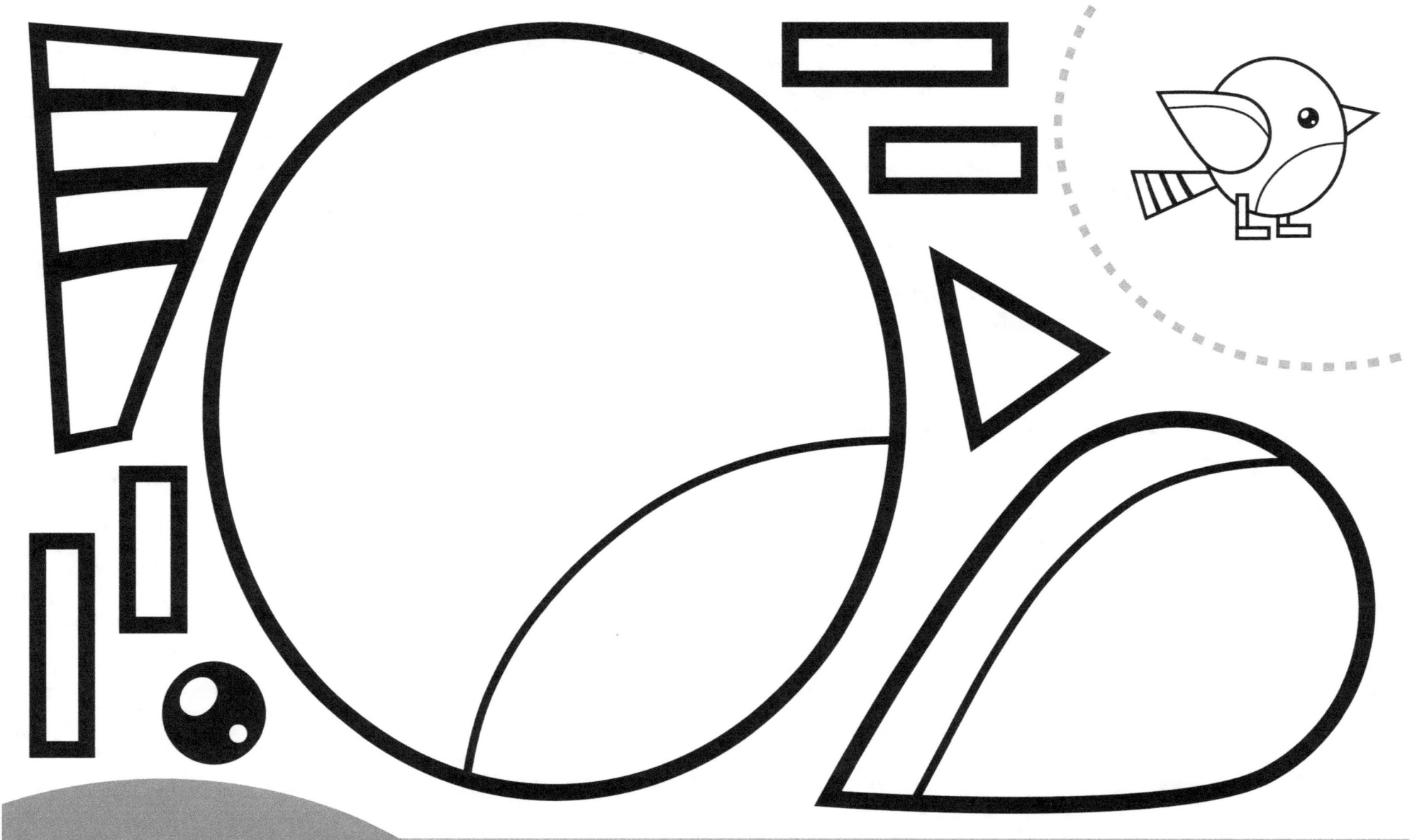

Cut & Glue

COLOR 1 — CUT OUT 2 — GLUE 3 — USE EXAMPLE OR YOUR IMAGINATION

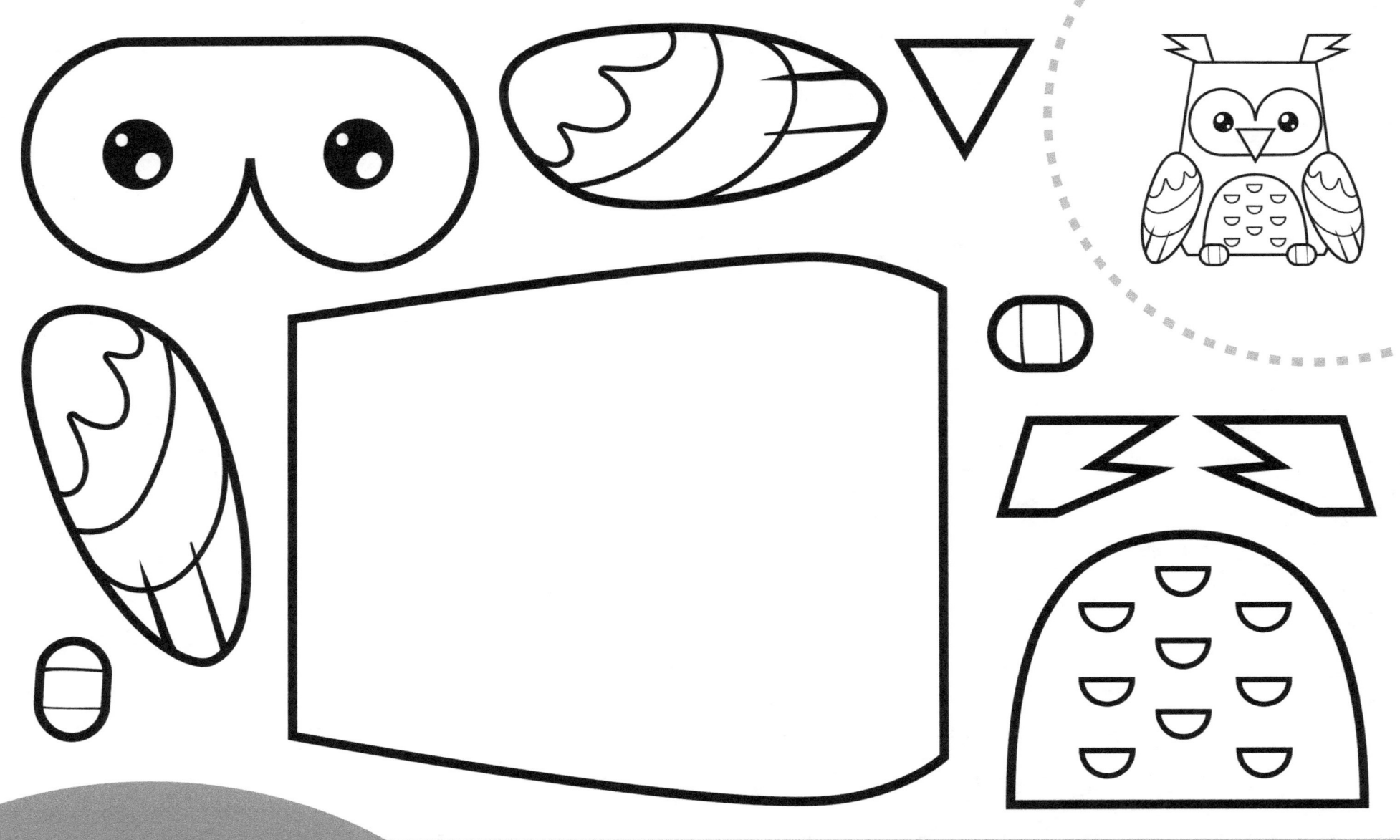

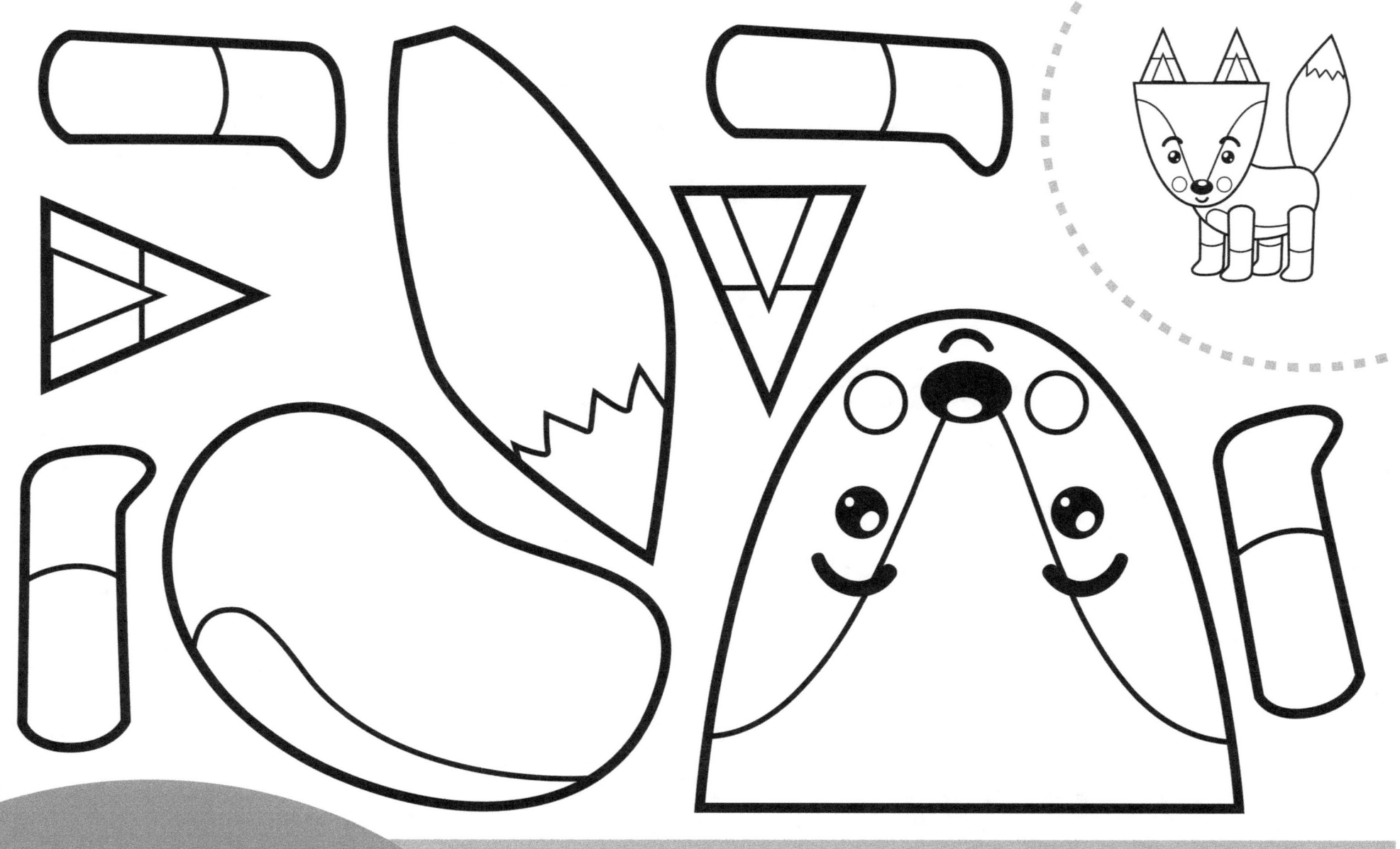

CUT & GLUE

COLOR 1 CUT OUT 2 GLUE 3 USE EXAMPLE OR YOUR IMAGINATION

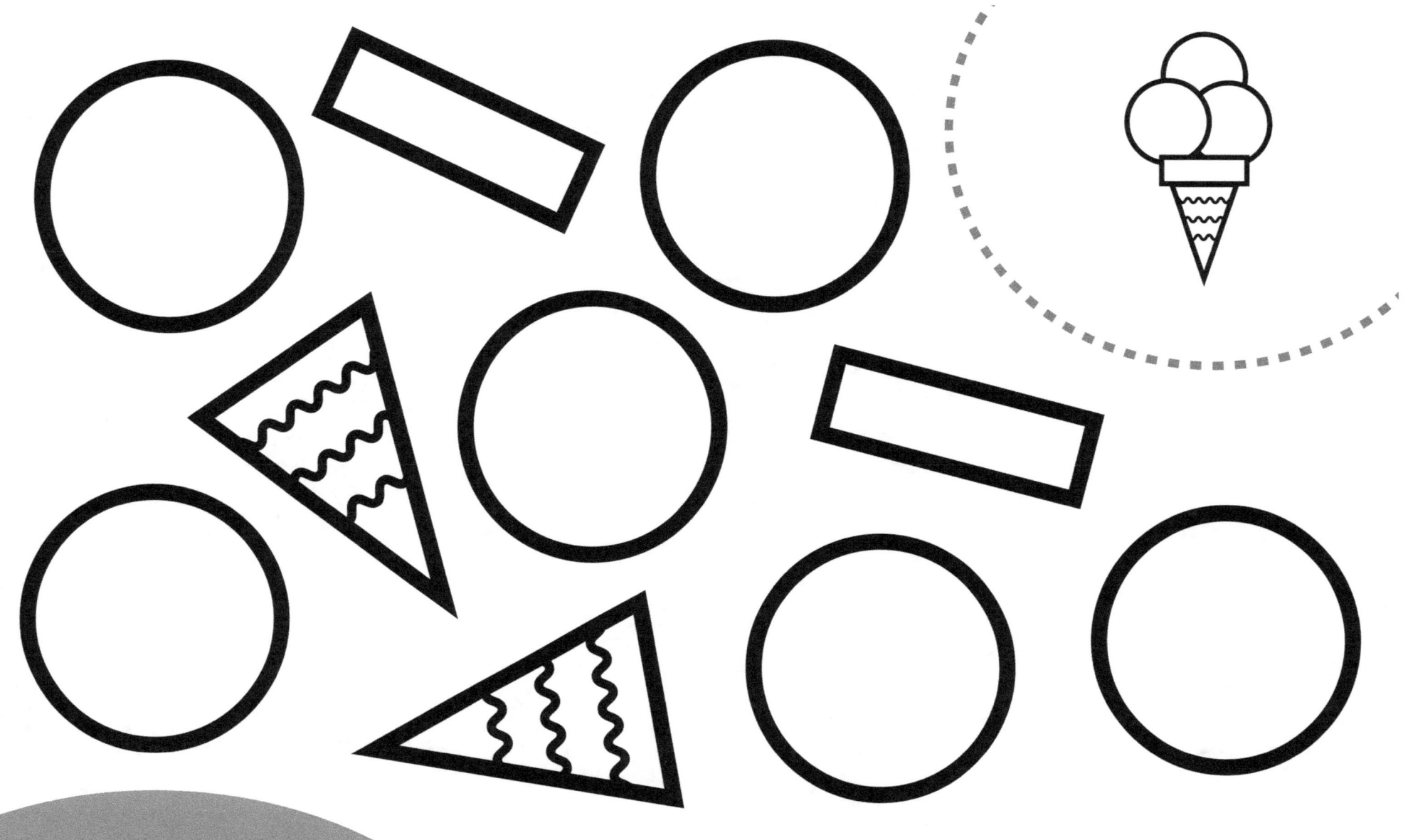

Cut & Glue

COLOR 1 / CUT OUT 2 / GLUE 3 / USE EXAMPLE OR YOUR IMAGINATION

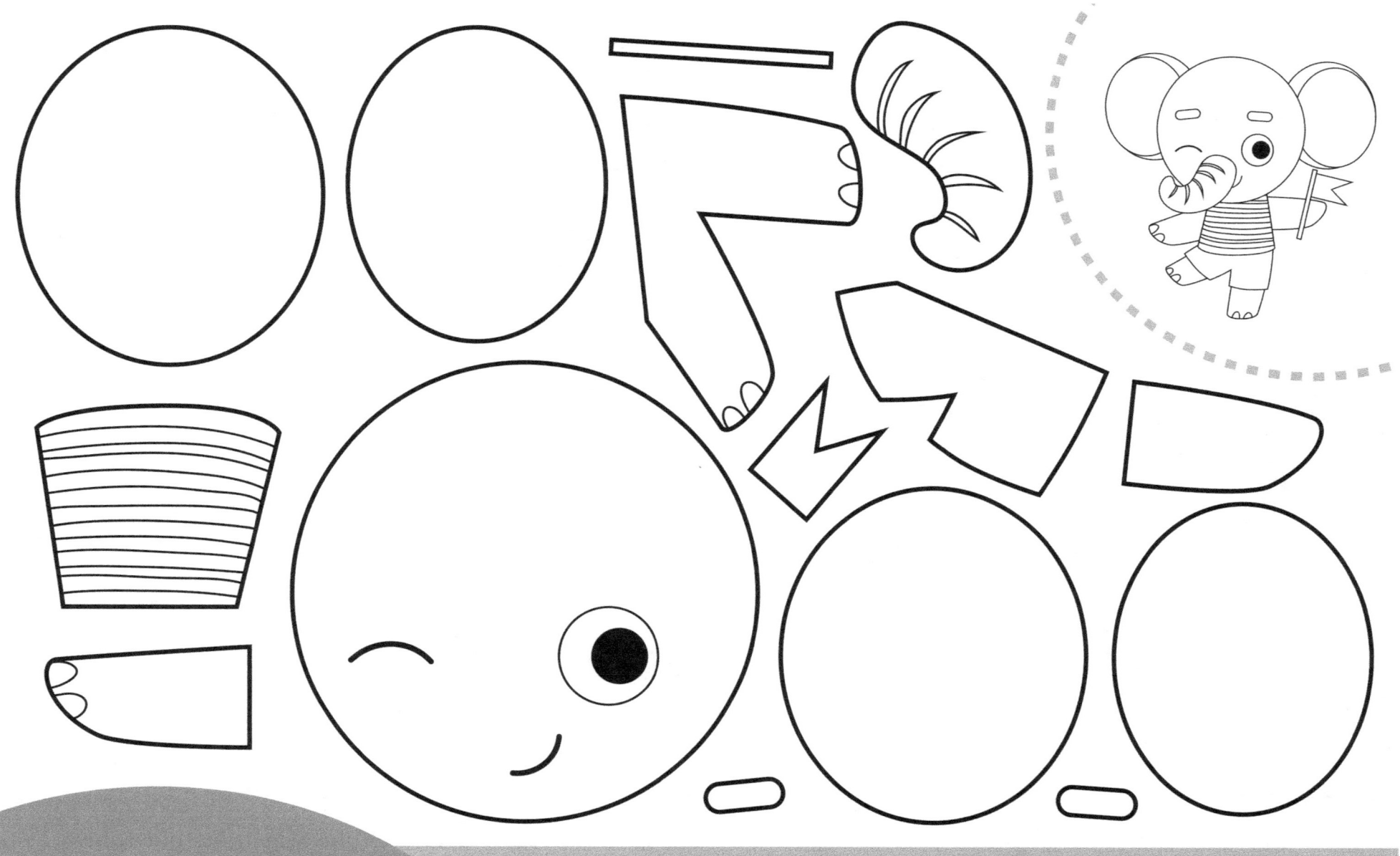

CUT & GLUE

COLOR CUT OUT GLUE USE EXAMPLE OR YOUR IMAGINATION
1 2 3

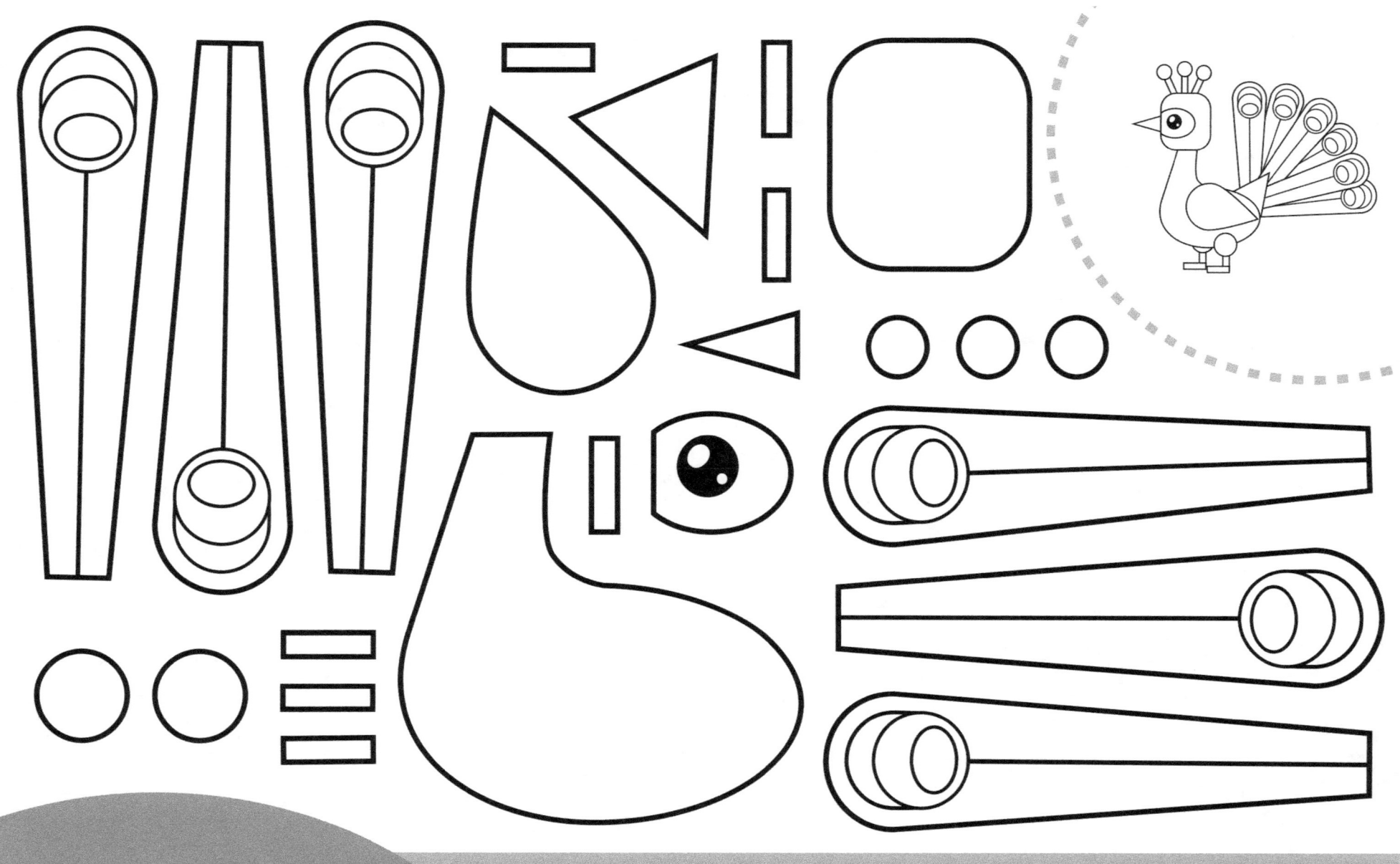

CUT & GLUE

COLOR 1 — CUT OUT 2 — GLUE 3 — USE EXAMPLE OR YOUR IMAGINATION

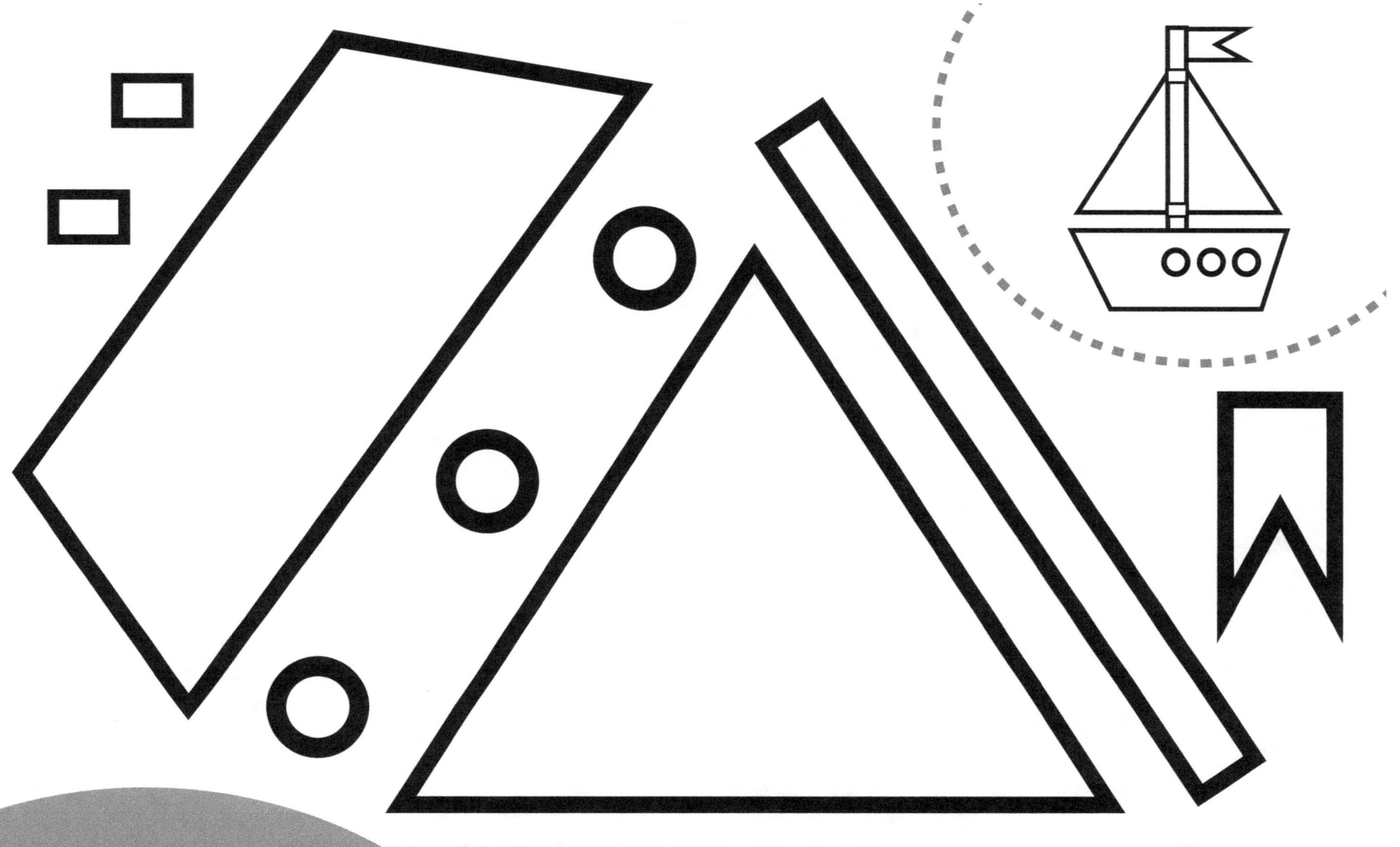

CUT & GLUE

COLOR 1 CUT OUT 2 GLUE 3 USE EXAMPLE OR YOUR IMAGINATION

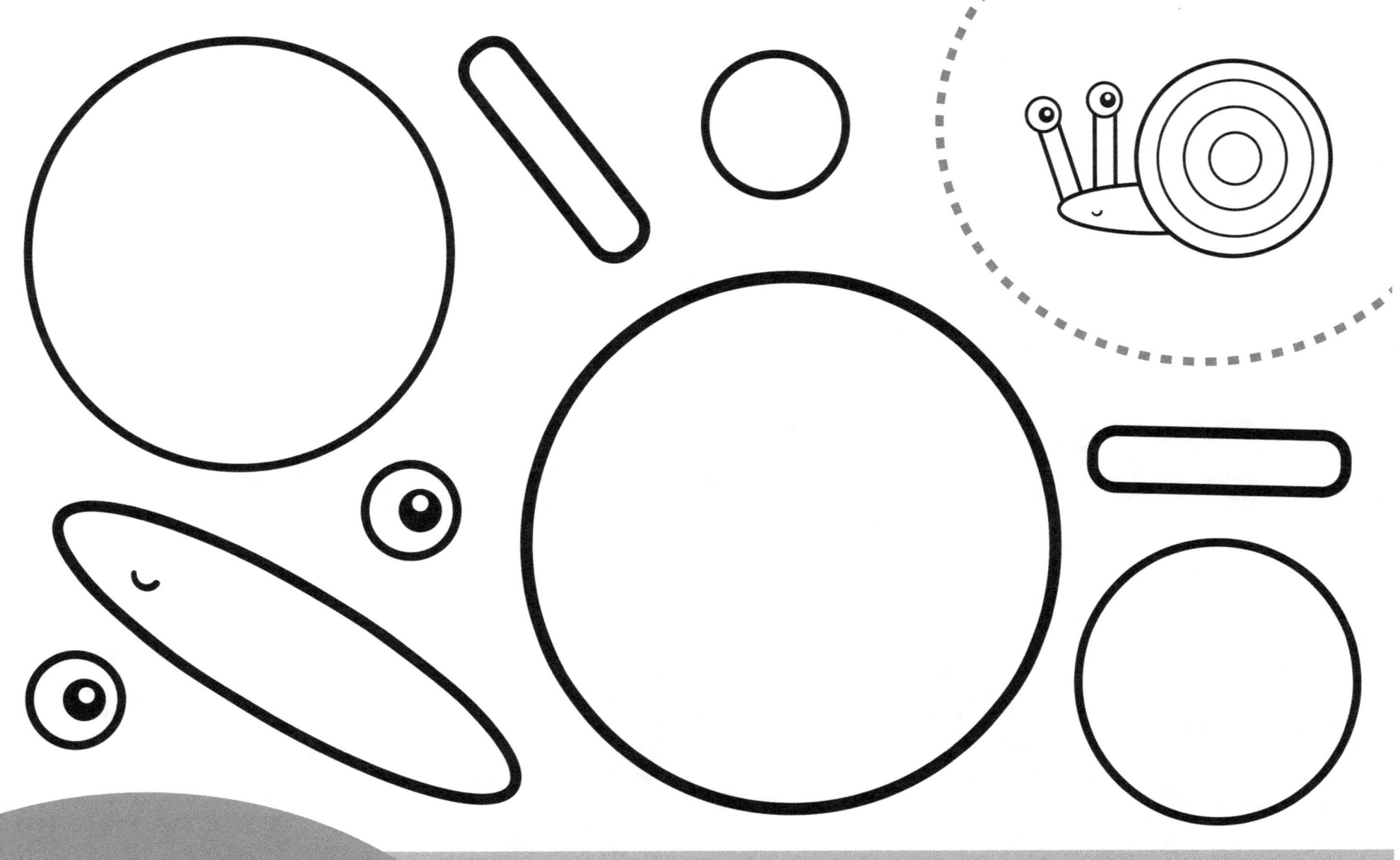

CUT & GLUE — COLOR 1, CUT OUT 2, GLUE 3, USE EXAMPLE OR YOUR IMAGINATION

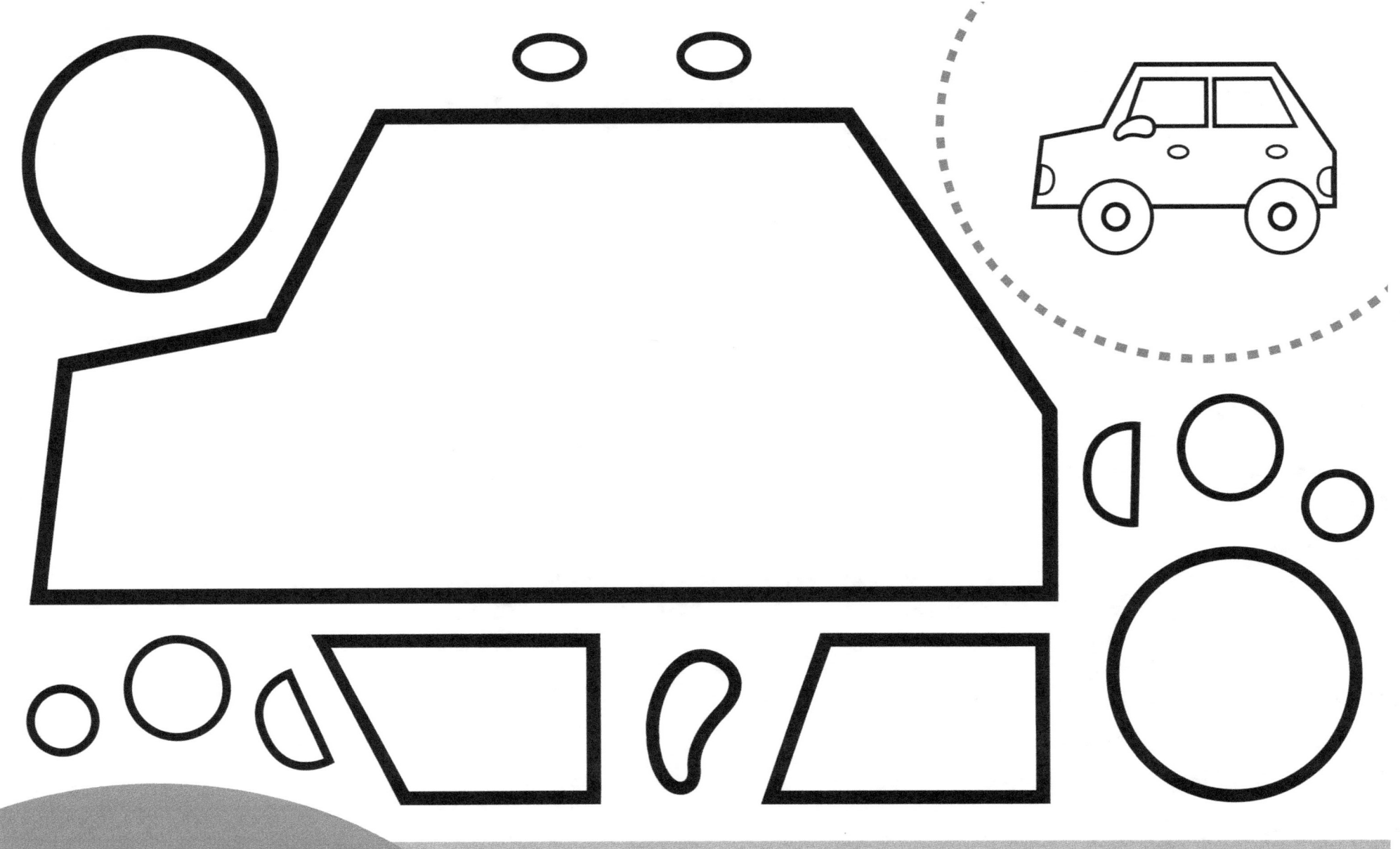

CUT & GLUE

COLOR 1

CUT OUT 2

GLUE 3

USE EXAMPLE OR YOUR IMAGINATION

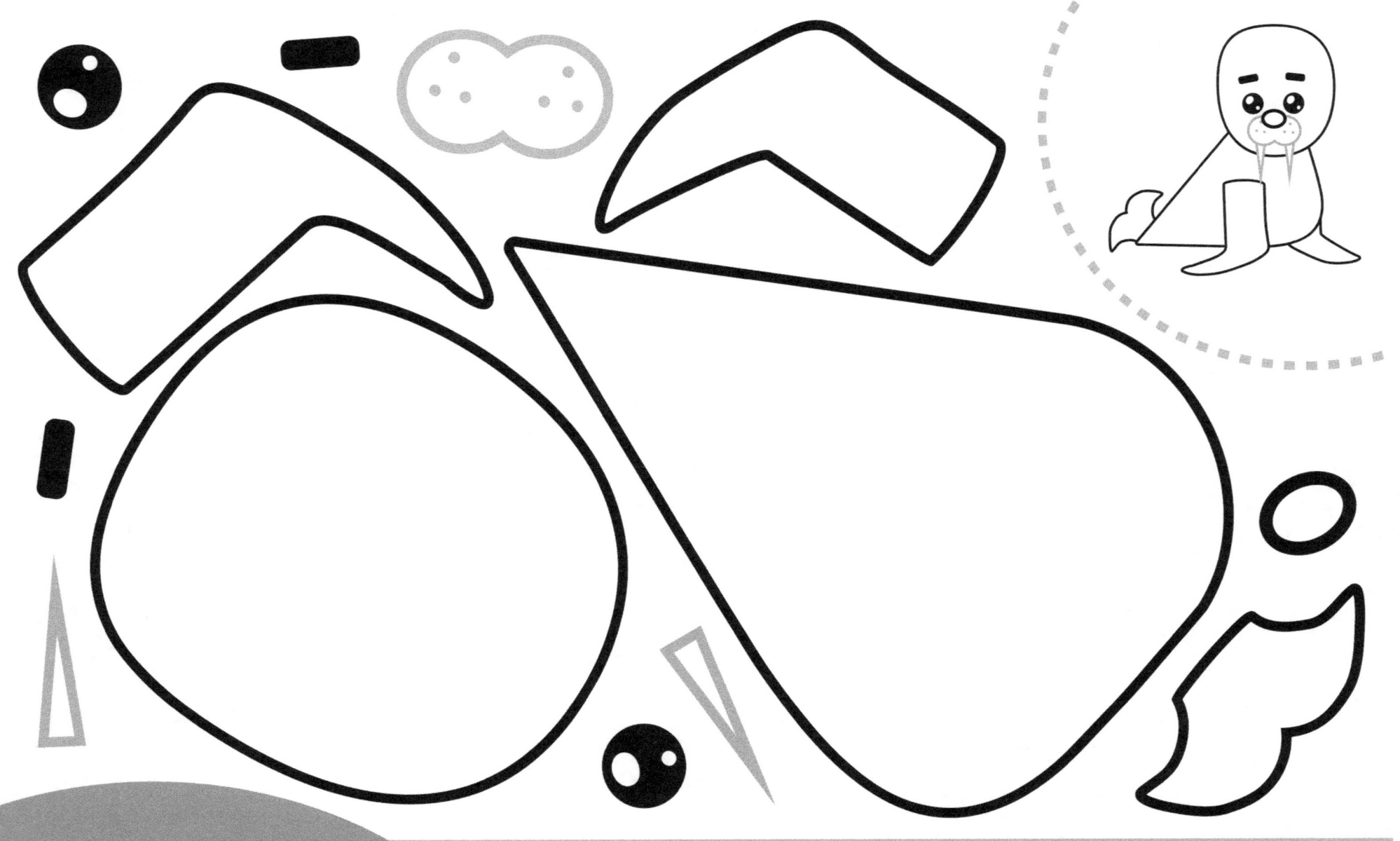

Cut & Glue

COLOR 1 — CUT OUT 2 — GLUE 3 — USE EXAMPLE OR YOUR IMAGINATION

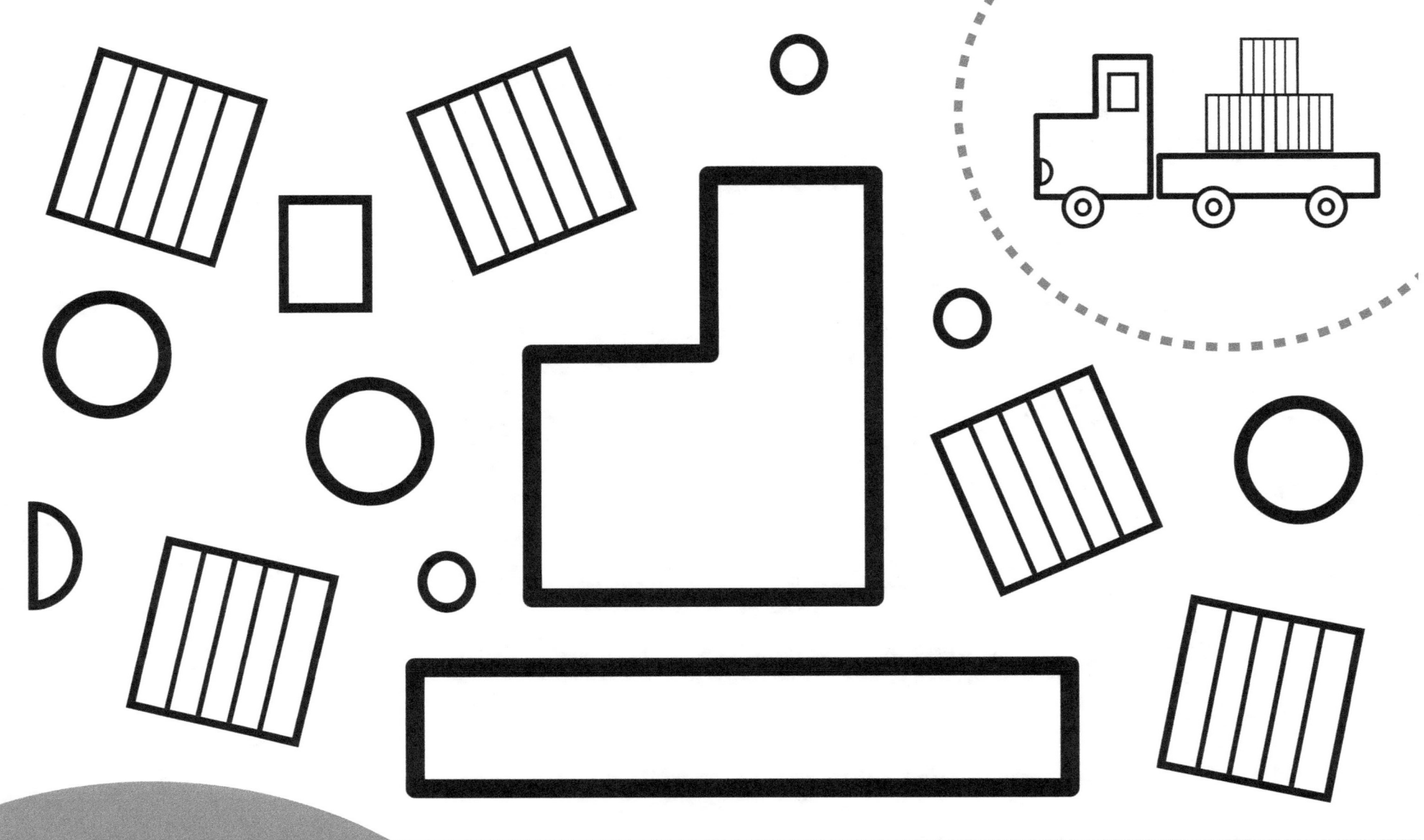

Cut & Glue

COLOR 1 · **CUT OUT** 2 · **GLUE** 3 · USE EXAMPLE OR YOUR IMAGINATION

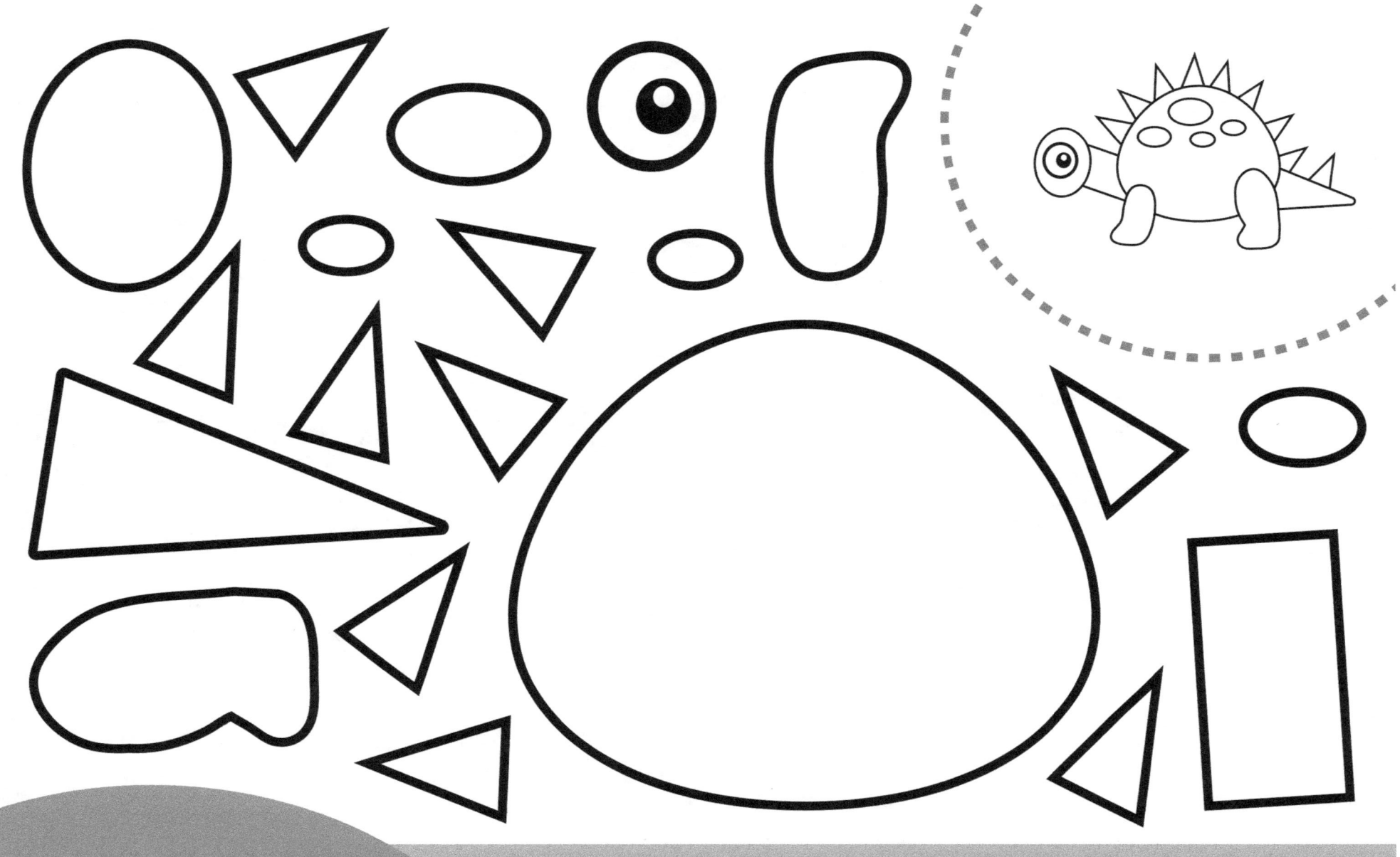

Cut & Glue

COLOR 1 · CUT OUT 2 · GLUE 3 · USE EXAMPLE OR YOUR IMAGINATION

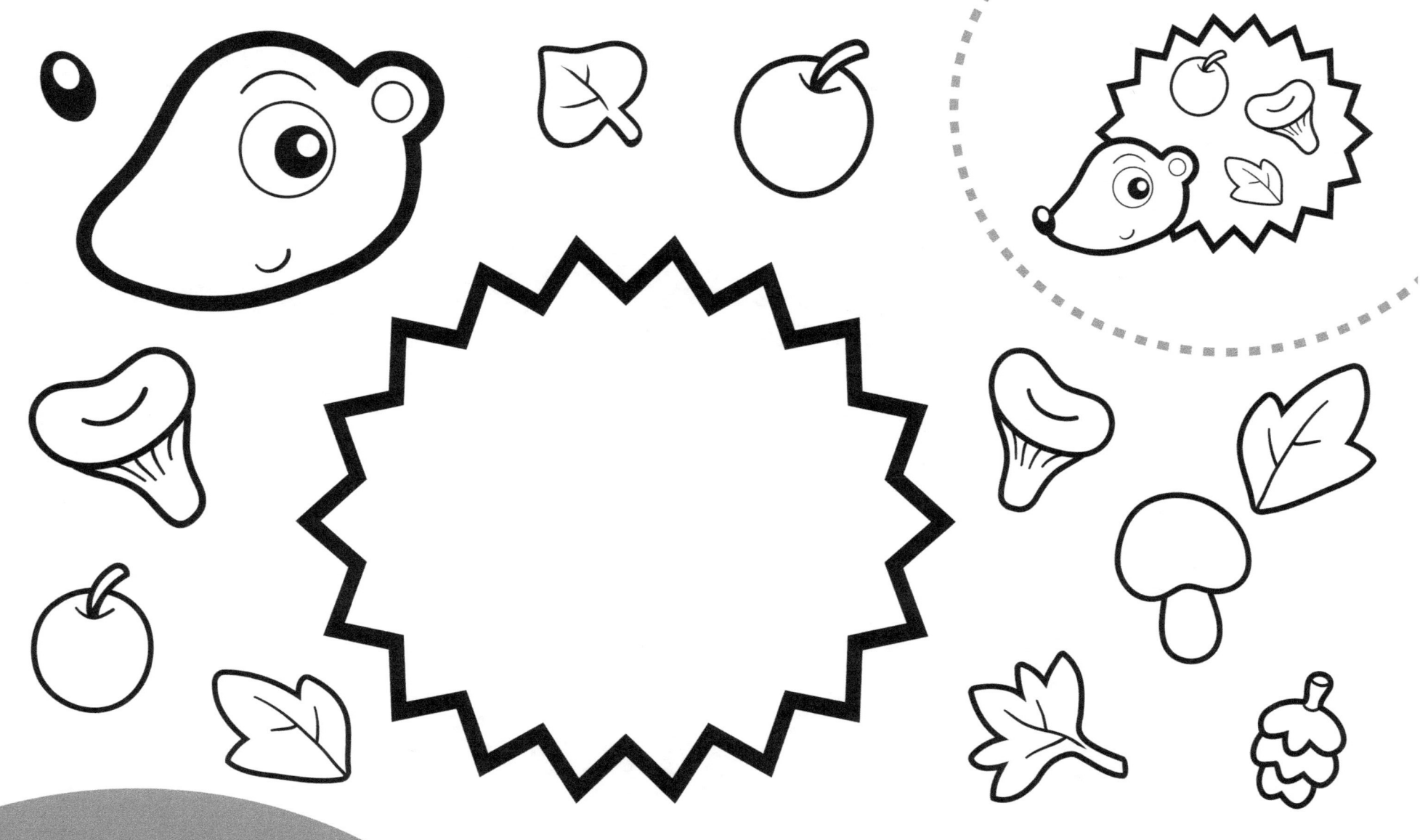

Cut & Glue

COLOR CUT OUT GLUE USE EXAMPLE OR YOUR IMAGINATION
1 2 3

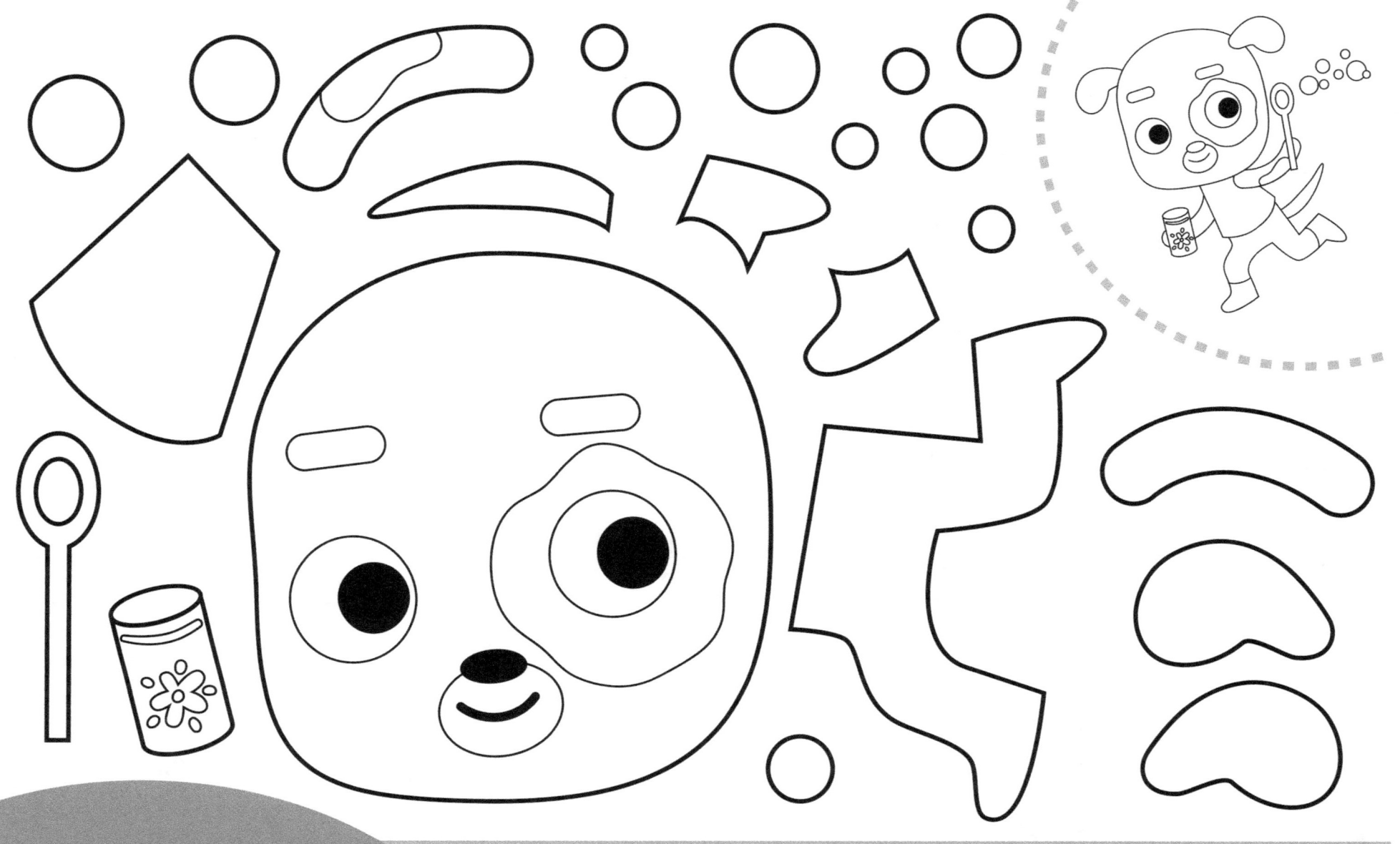

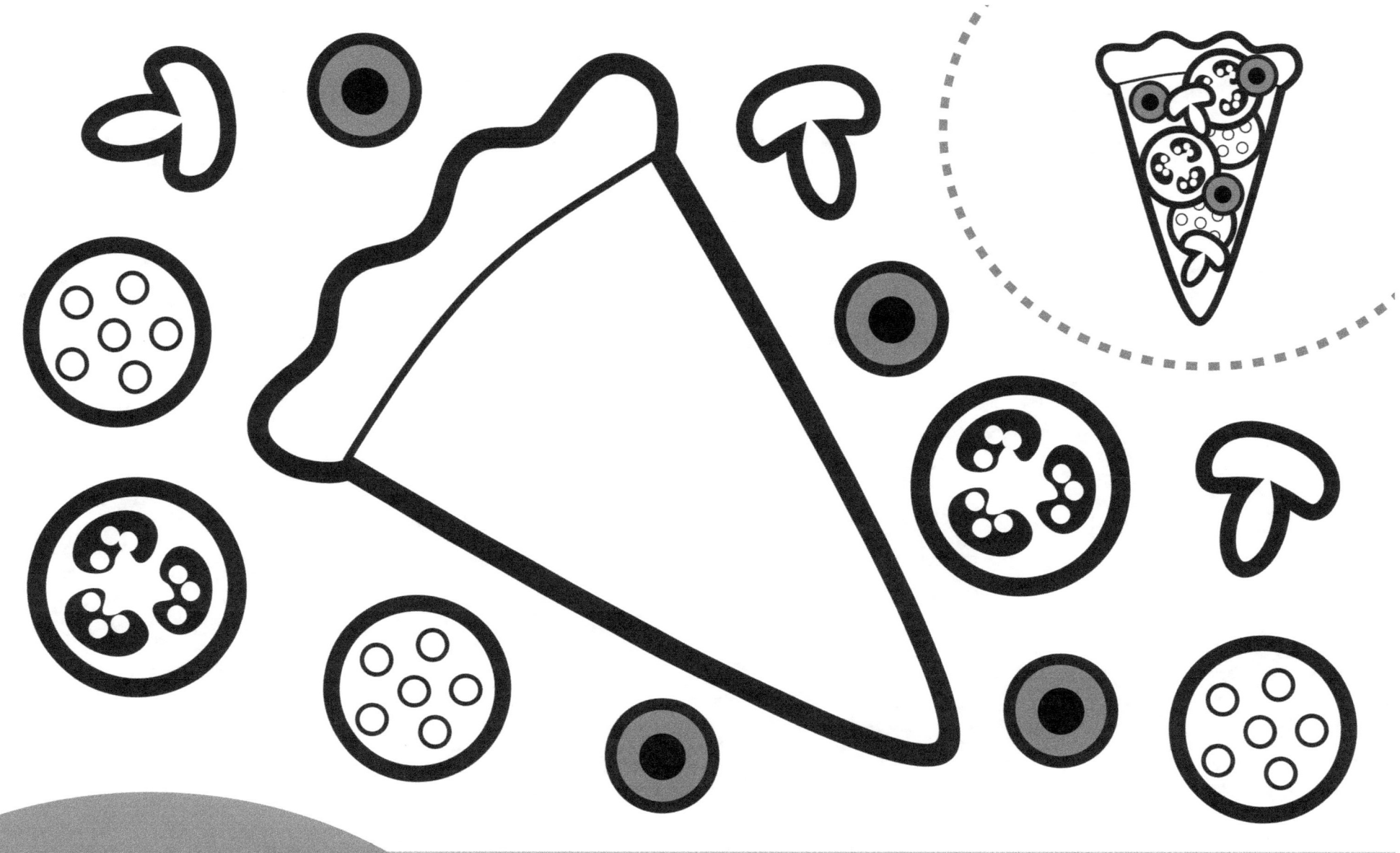

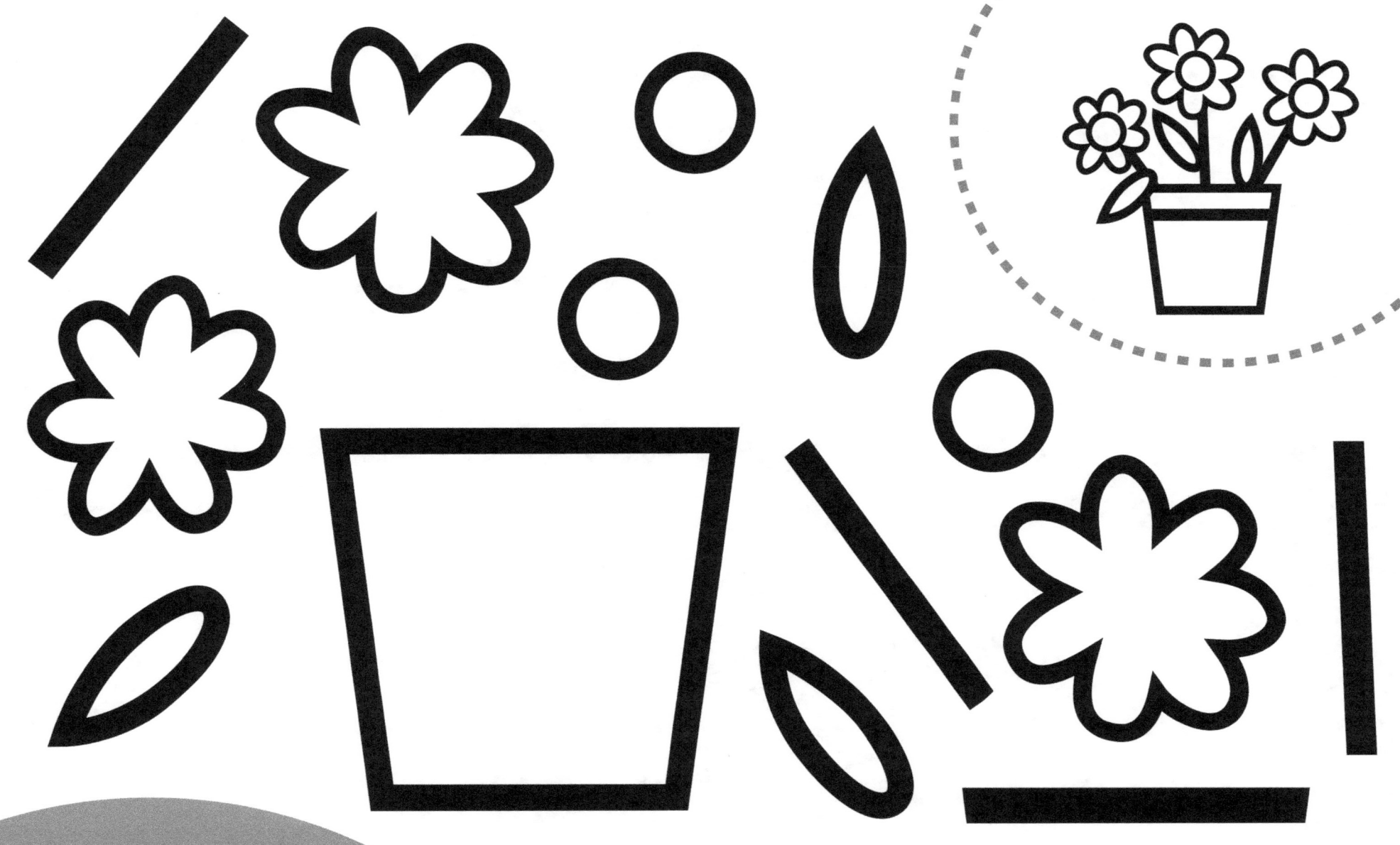

Cut & Glue

COLOR 1 · CUT OUT 2 · GLUE 3 · USE EXAMPLE OR YOUR IMAGINATION

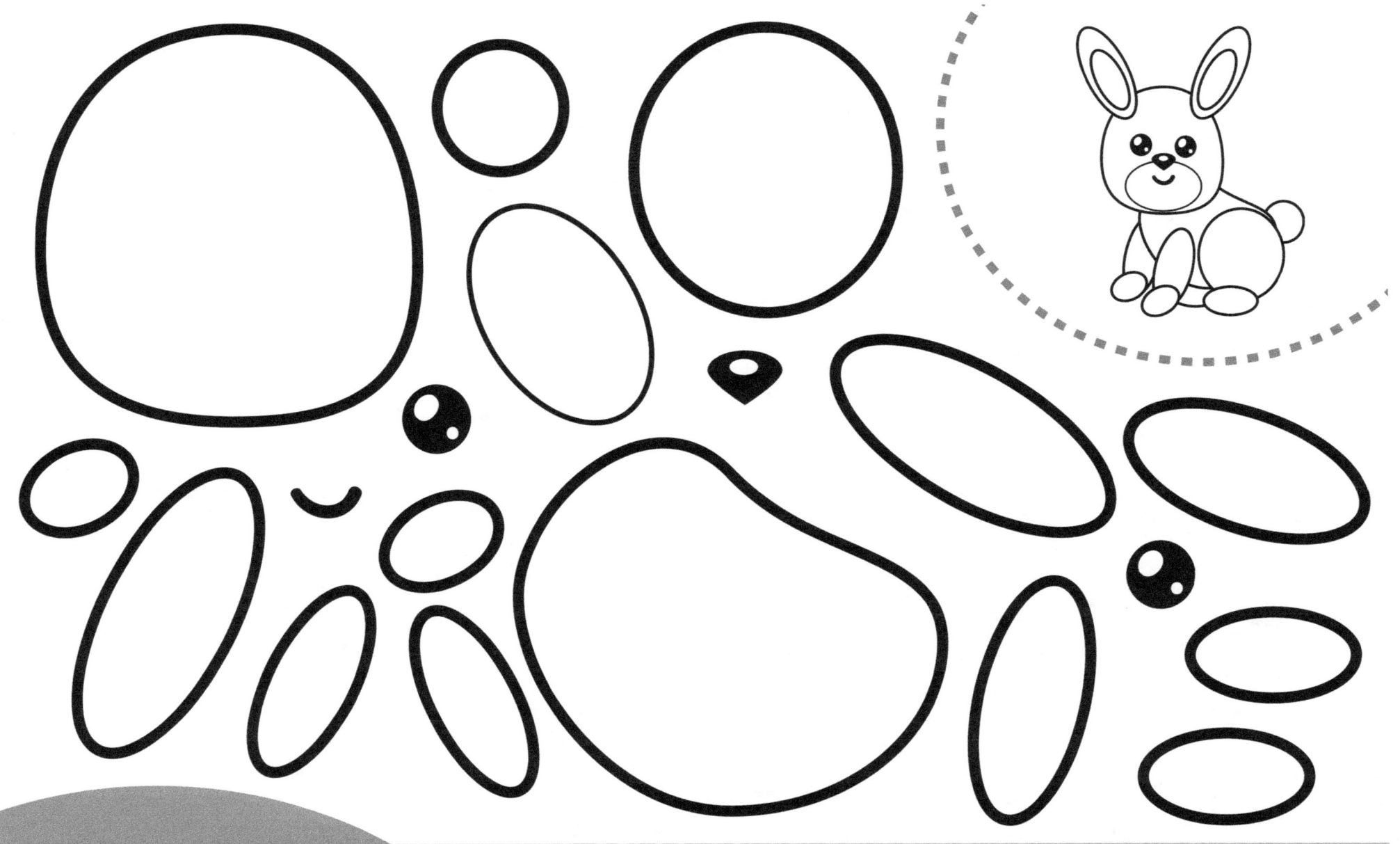

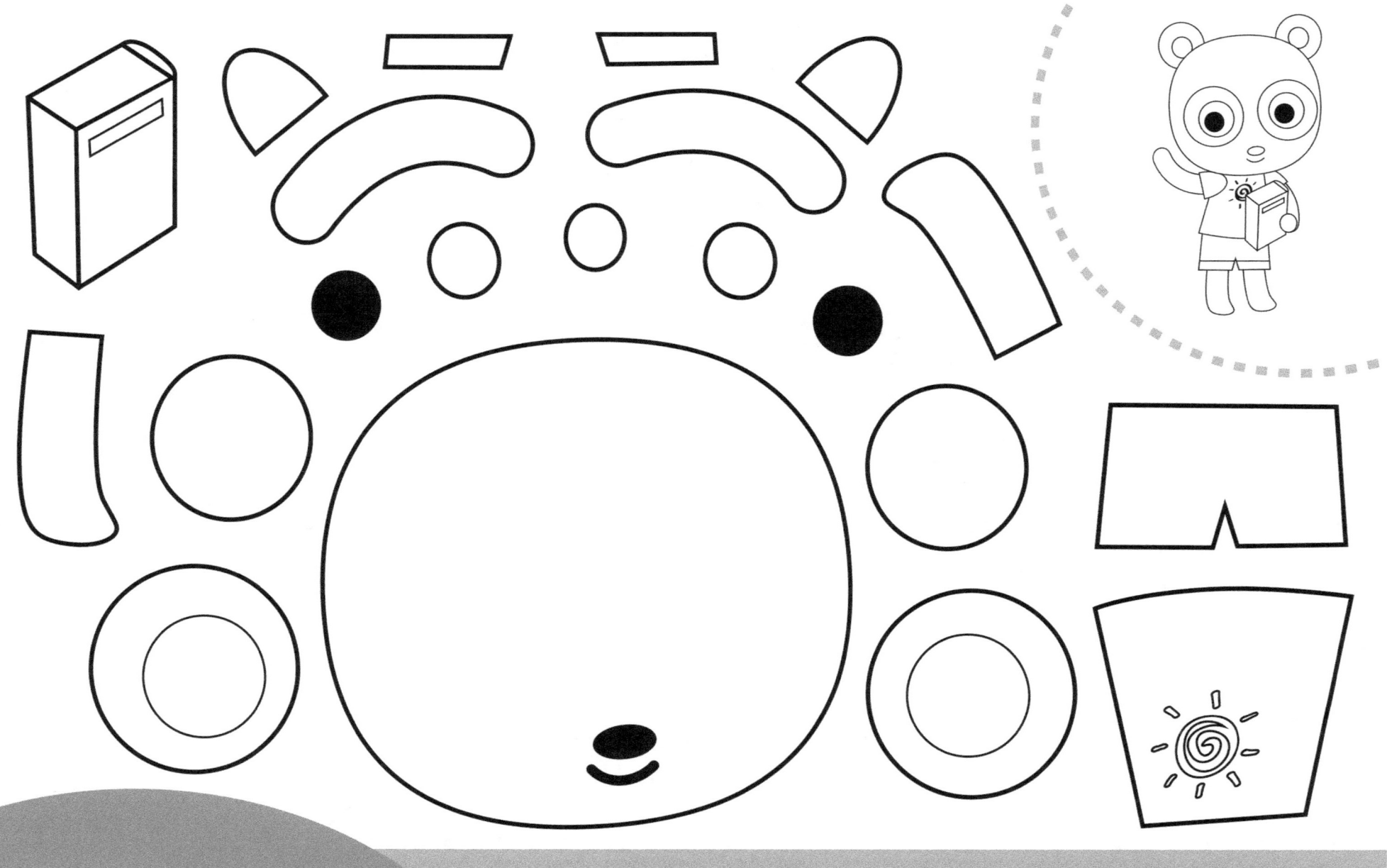

CUT & GLUE

COLOR CUT OUT GLUE USE EXAMPLE OR YOUR IMAGINATION
1 2 3

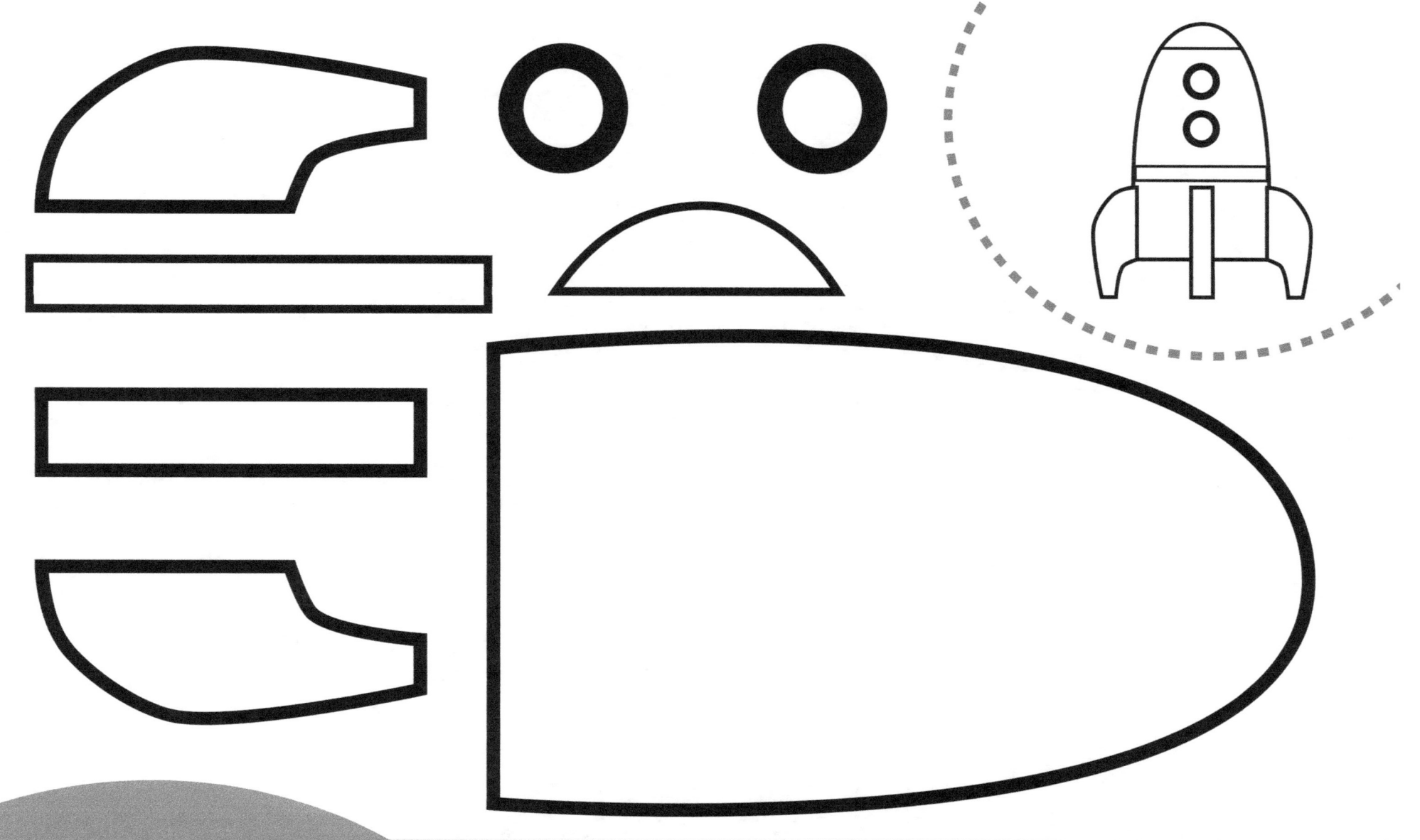

CUT & GLUE

COLOR 1 | CUT OUT 2 | GLUE 3 | USE EXAMPLE OR YOUR IMAGINATION

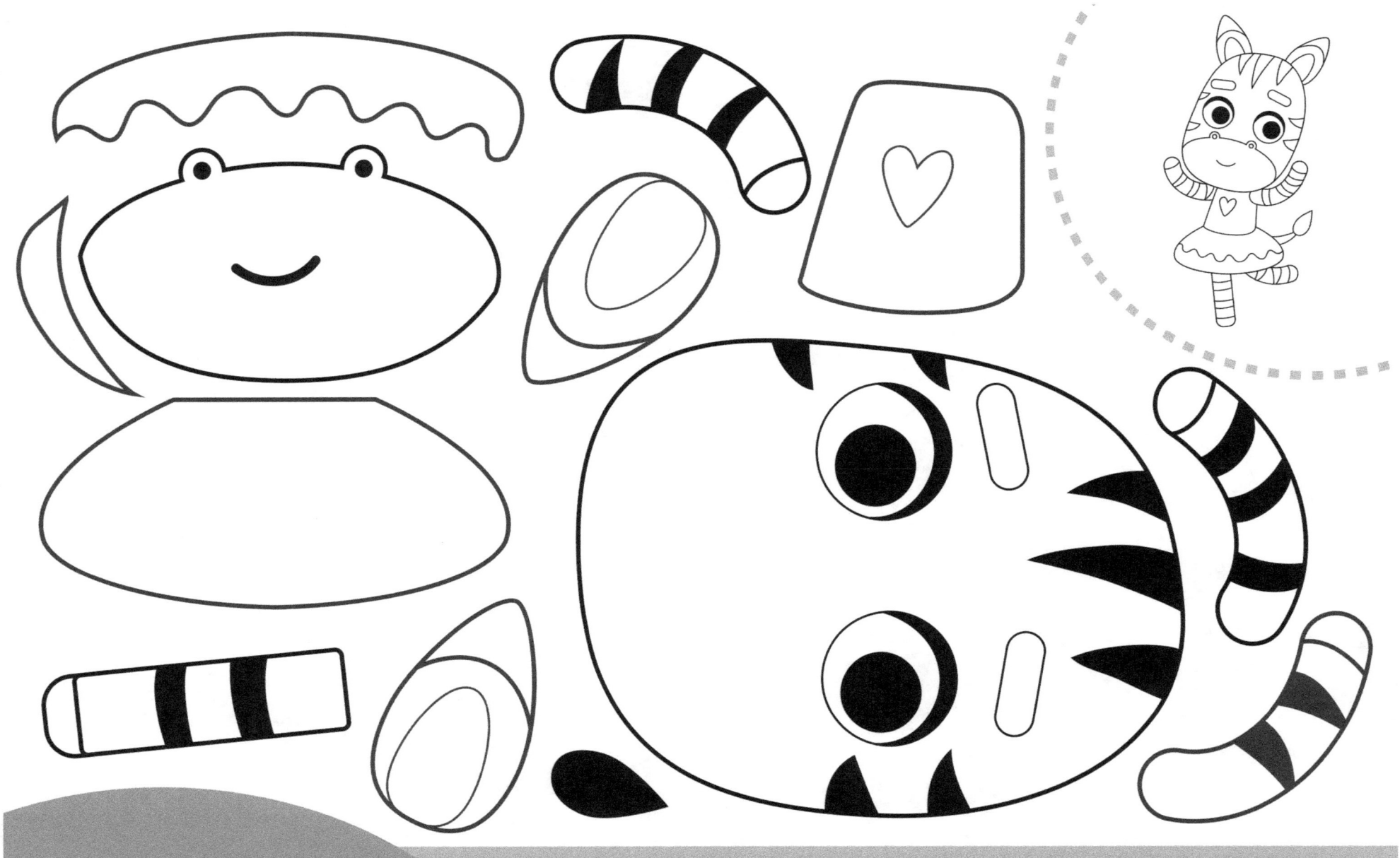

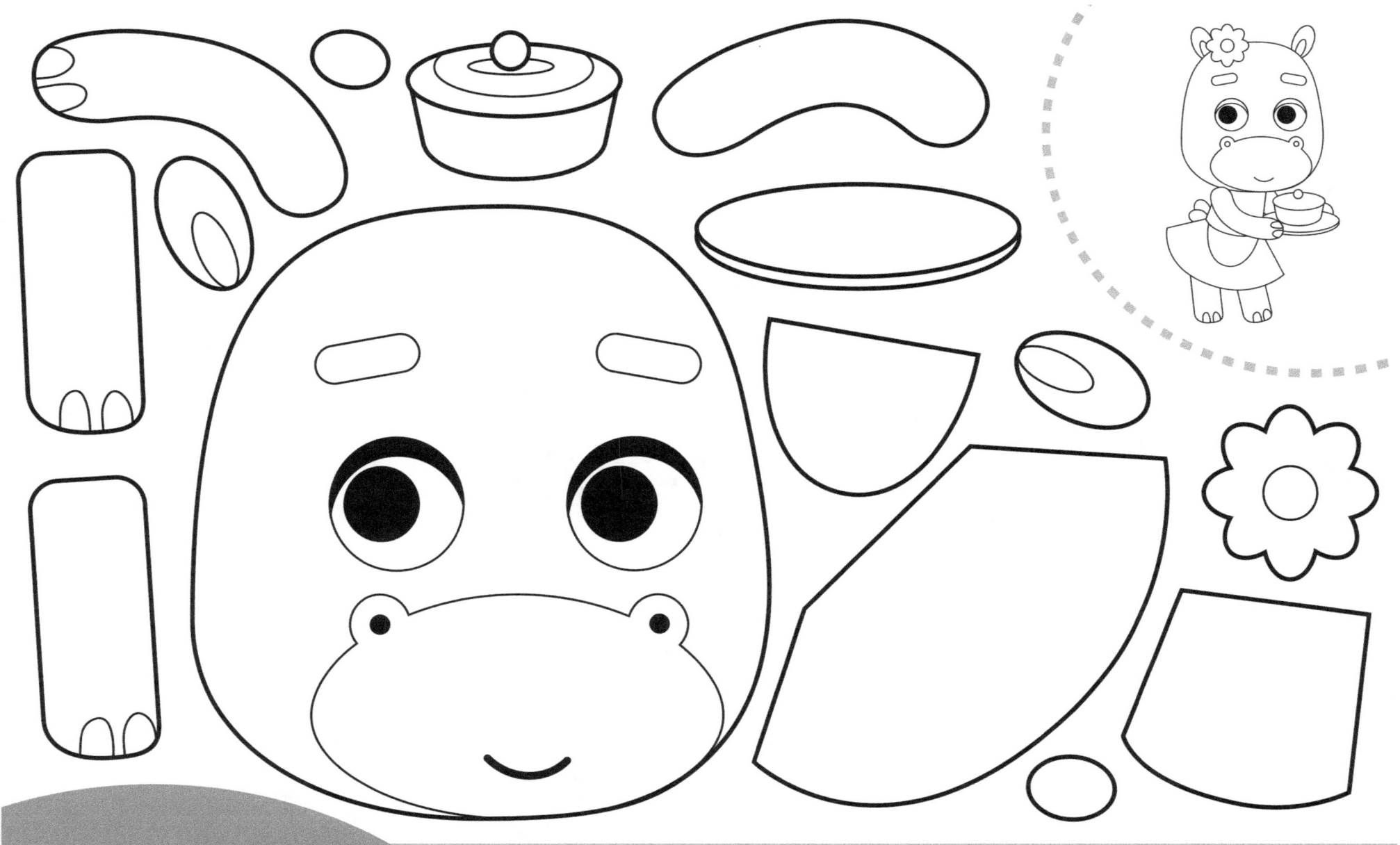

Cut & Glue

COLOR 1 — CUT OUT 2 — GLUE 3 — USE EXAMPLE OR YOUR IMAGINATION

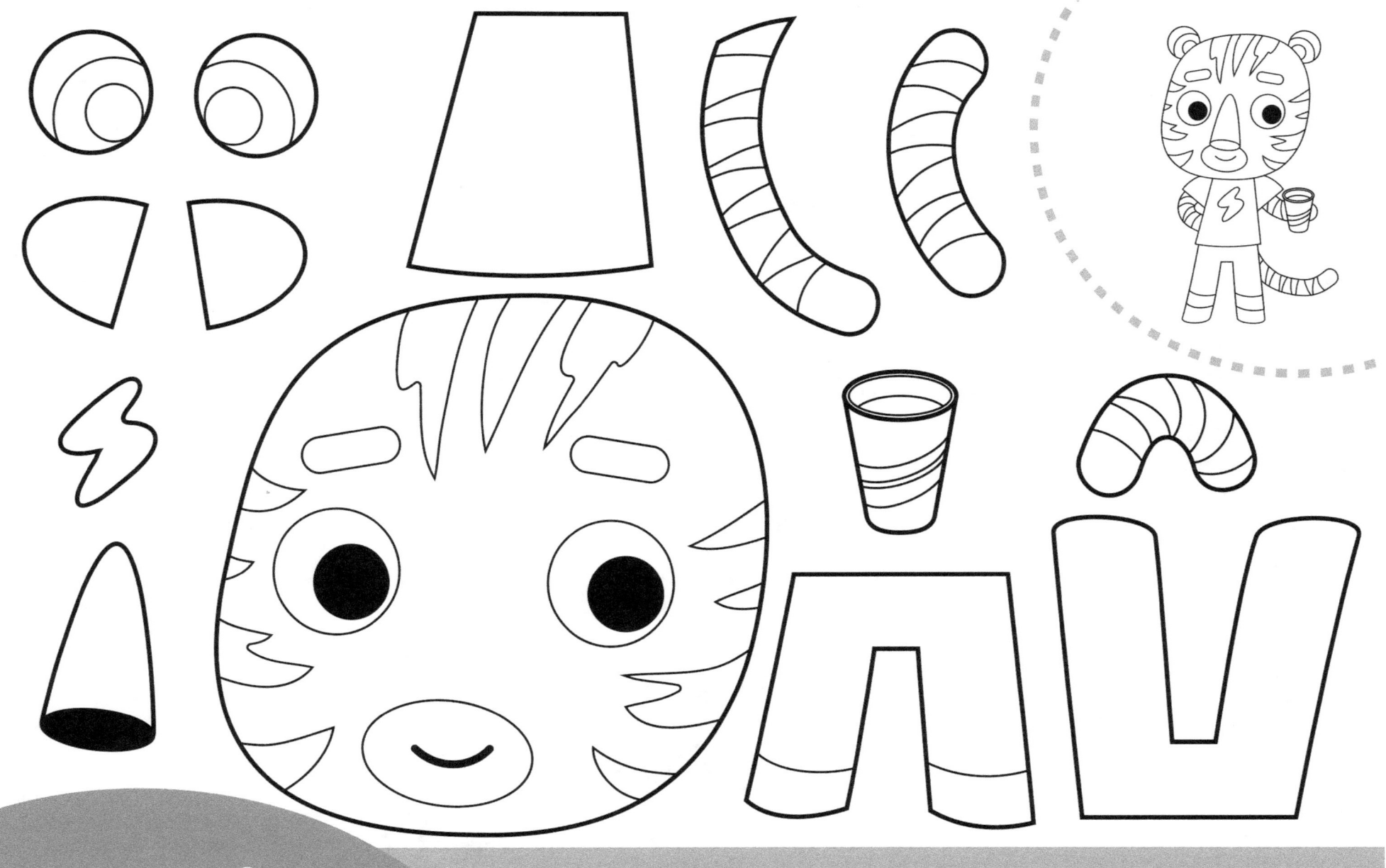

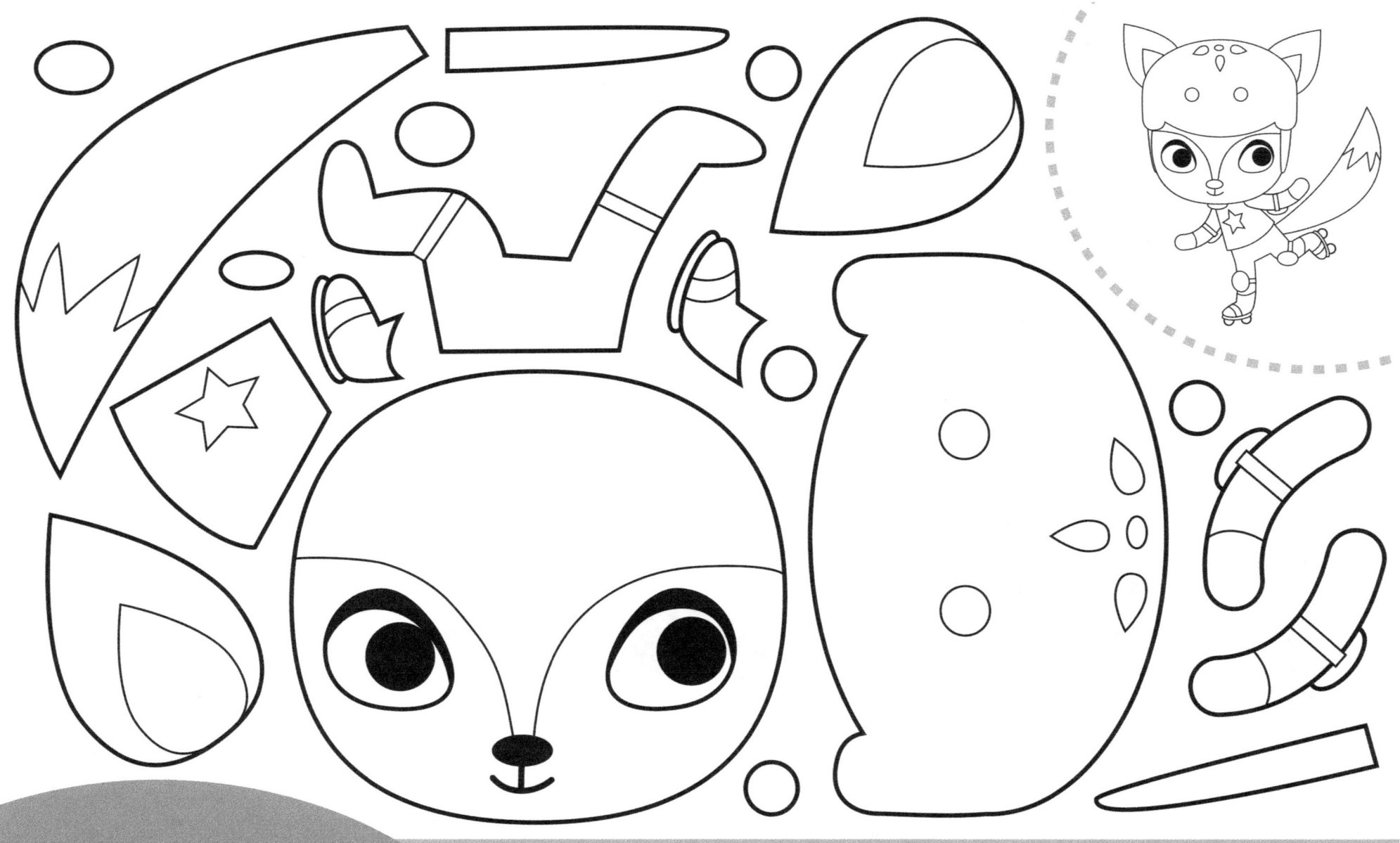

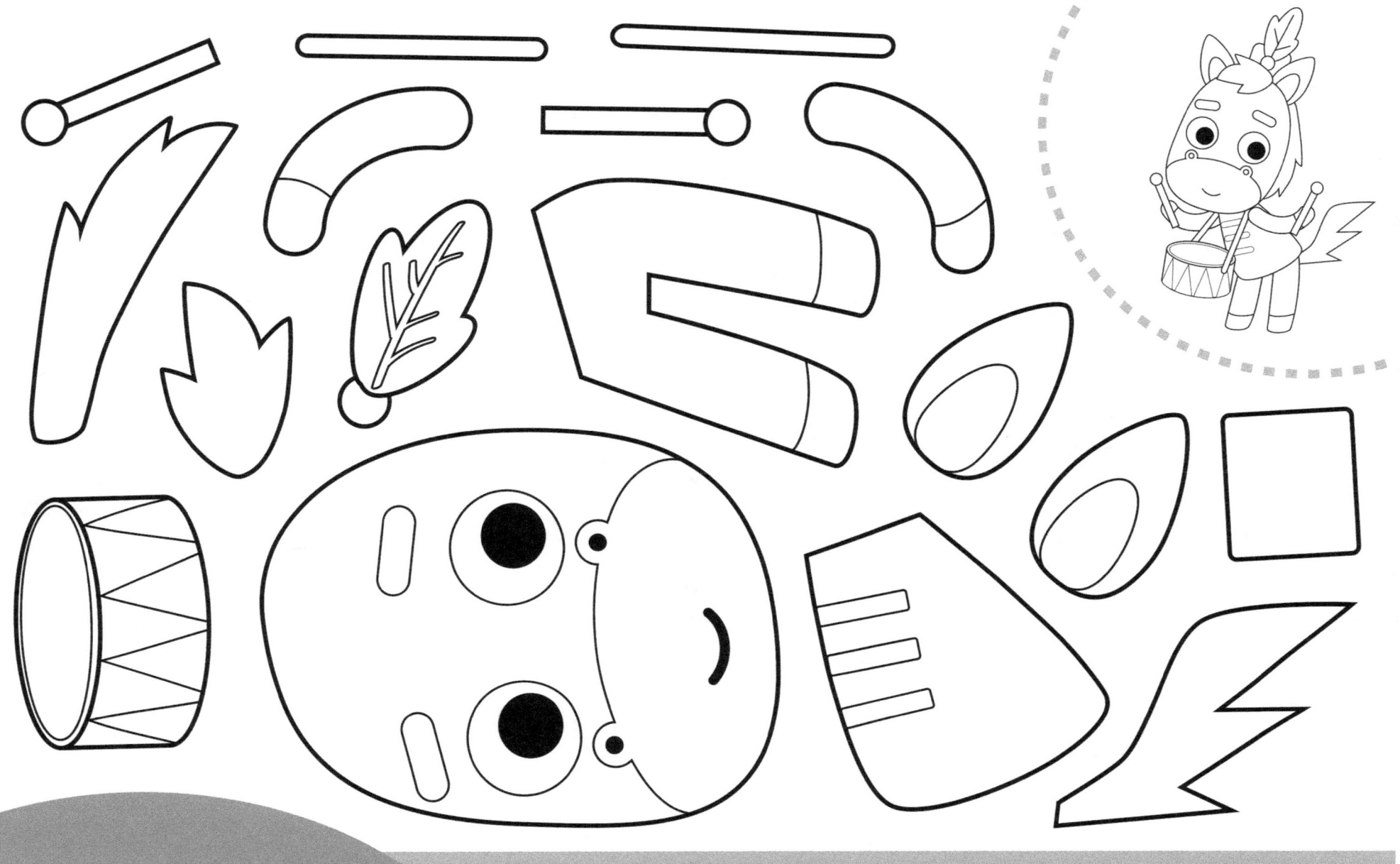

Cut & Glue

COLOR 1

CUT OUT 2

GLUE 3

USE EXAMPLE OR YOUR IMAGINATION

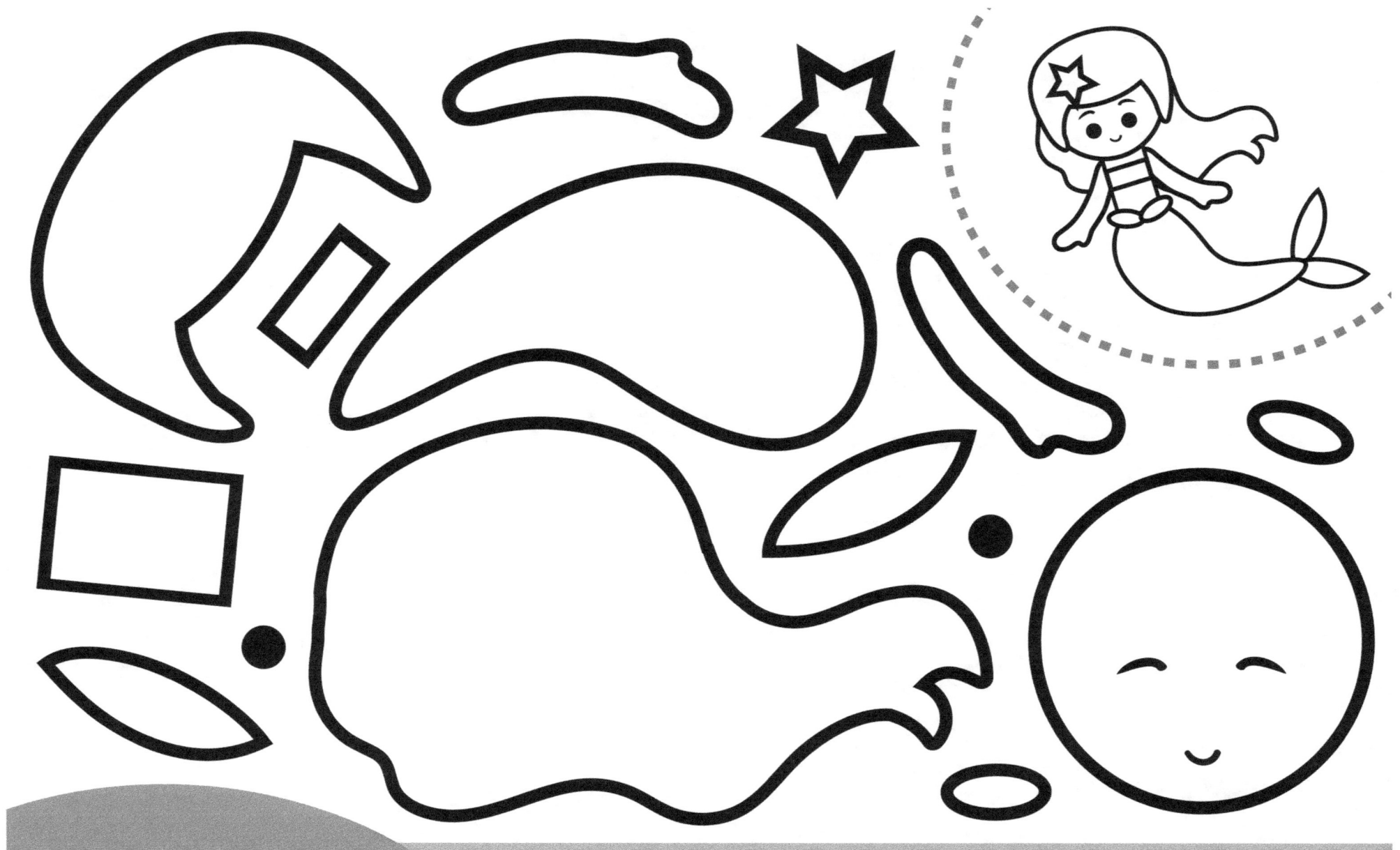

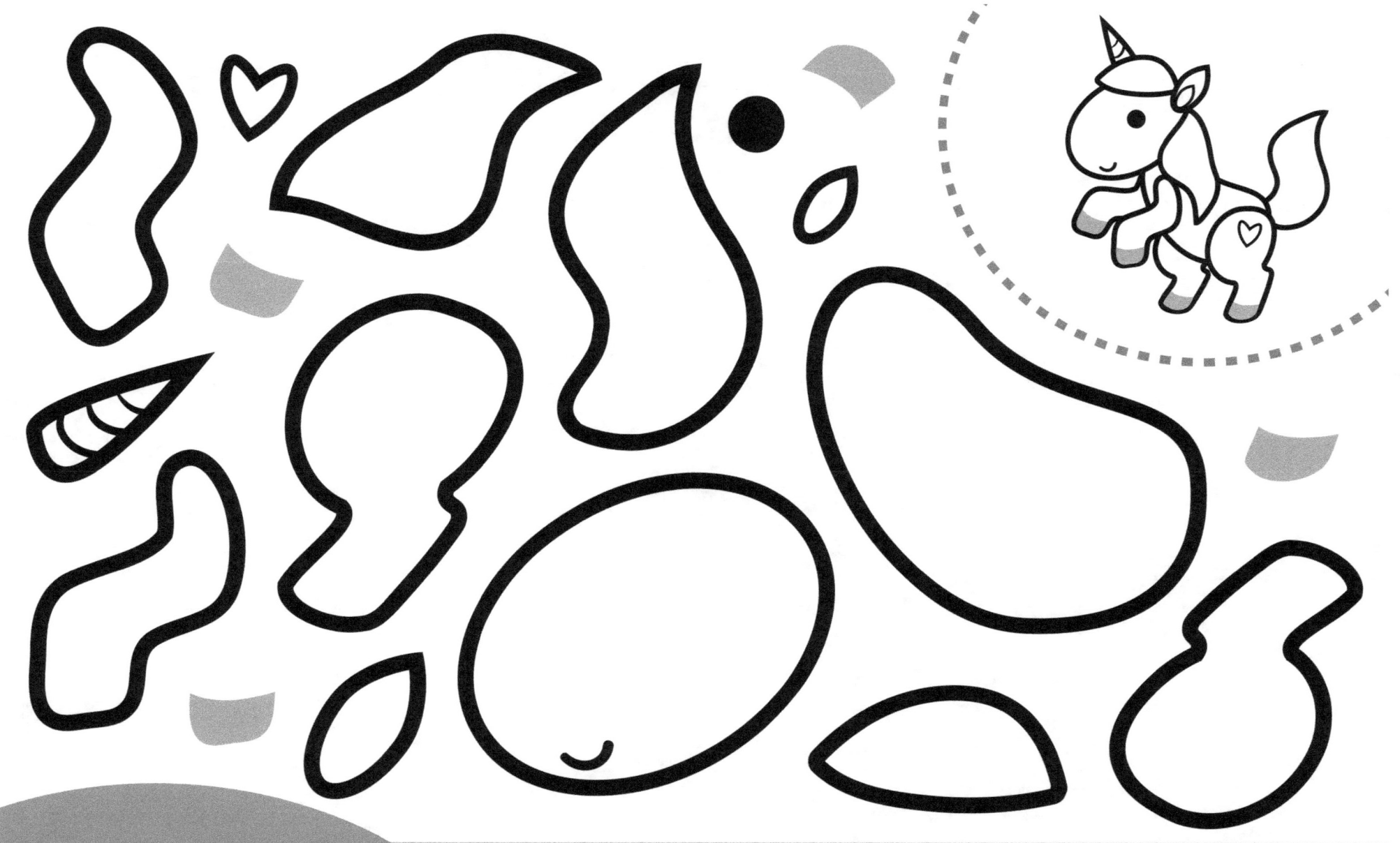

Cut & Glue

COLOR 1 · CUT OUT 2 · GLUE 3 · USE EXAMPLE OR YOUR IMAGINATION